THE Fantasy Art Bible

Edited by Jackie Strachan and Jane Moseley

CHARTWELL
BOOKS, INC.

A QUARTO BOOK

This edition published in 2009 by
CHARTWELL BOOKS, INC.
A division of BOOK SALES, INC.
276 Fifth Avenue Suite 206
New York, New York 10001
USA

Reprinted 2010, 2012

ISBN-13: 978-0-7858-2552-4
ISBN-10: 0-7858-2552-5
QUAR: SFFA

This book was produced by
Quarto Publishing plc
The Old Brewery
6 Blundell Street
London N7 9BH

Picture researchers: Emma Shackleton and Sarah Bell
Designer: Chris Bell
Project managers: Jackie Strachan and Jane Moseley
Art director: Caroline Guest
Creative director: Moira Clinch
Publisher: Paul Carslake

Color separation by PICA Digital Pte Ltd, Singapore
Printed by Midas Printing International Limited, China

10 9 8 7 6 5 4 3

Contents

Introduction

Fantasy art is the art of the imagination. Its scope is endless and its boundaries without limit. This is the joy of the best fantasy, whether you are a creator or a "consumer": in all its forms, fantasy offers you a boundless imaginative playground in which to revel. This does not mean that working in this field can be an exercise in self-indulgence. Discipline is important if you are to become successful, but fantasy offers you a freer rein than any other form of art. Indeed, it is based on the fact that the artist allows her or his imagination to roam and explore.

The spectrum of fantasy

Fantasy appears in four main forms: art, the written word, comics, and movies. Unlike the case in almost any other genre of creativity, the underpinning of these four forms is identical: the means of communication may differ, but there is no firm boundary, in terms of creativity, between the different aspects of fantasy. All of them depend for their success on the flow of ideas and the development of an initial, original idea into something fully realized. There might seem to be a gap between written fantasy and fantasy art. However, the guiding thrust is much the same. Both are exercises of the imagination, the expression of

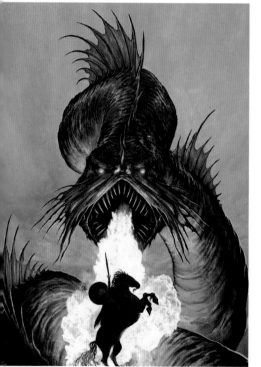

Kelpie

Martin McKenna's beast is a malevolent creature from Celtic folklore. It dwarfs the brave warrior who dares to call it from its watery kingdom in the deep lochs of Scotland.

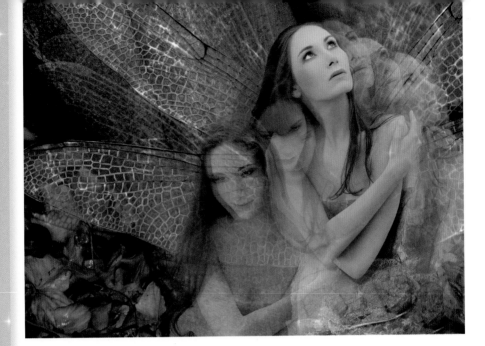

creative ideas. Both explore the conceptual freedom that fantasy allows. Ideas are freely exchanged between the two modes of expression.

A fantasy artist setting out to create a new artwork must go through the same thought-processes—must enter the same mindset—as a fantasy writer embarking on a new novel. Where will my original idea lead to? Do I want to think it out now, or do I want my imagination to lead me on a journey whose destination I will discover only when I get there? Through what and how many conceptual realms will the audience be prepared to follow me? How far can I stray from the orthodox? Of course, not all fantasy artists think this way—there is plenty of mediocre, unimaginative fantasy art around, just as there is plenty of mediocre fantasy fiction—but the best of them are working to discover new areas of the great fantasy playground. This parallel holds good also for the creators of comics and movies.

Another point to remember is that many of the best fantasy paintings are narrative. They may present you with only a single event, but that depiction challenges you to imagine for yourself two different stories: what has happened before, and what will happen afterward.

Alar 2

This image by Vanessa Gaye-Schiff is ambiguous and beguiling. Do the "knocked-back" images of the woman represent her alter ego? Her golden wings shimmer in the background.

Where do you get all those crazy ideas from?

This is the question that, traditionally, all fantasy creators must face from time to time. The equally traditional response is that some of them are already there in the real world, some are part of the common stockpot shared by all fantasists, and some of them just . . . arrived. The last category is the interesting one.

No one can teach imagination. At the same time, the old cliché—that you either have it or you don't—is not really true. All human beings have imagination; to take a simple example, we all think about our own futures, which is an imaginative act. Children often live in a world that is more fantastical than mundane. As we grow older, however, most of us determinedly inhibit our imaginations—we have to cope with the real world, in which fantasy is too often seen as having no part to play.

Wastelands

In a devastated landscape, under an ominous sky, a band of travelers take stock. Two strange birds fly overhead, the only other form of life in Howard Lyon's otherwise bleak and moody scene.

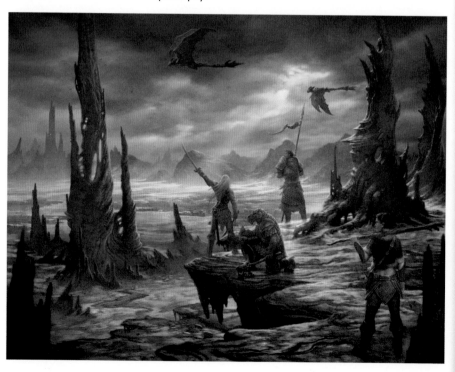

But imagination is not something that, once curbed, is lost forever. The trick of all fantasy creation is to rediscover the imaginativeness of childhood and then probably to add the disciplines of adulthood to give the fantastication form. It is no coincidence at all that some of the finest fantasy has been produced for children: through the re-exploration of childhood, adults can often regain that "magical land" they once inhabited. Childhood is only one of the playgrounds you can enter.

Anyone, no matter how imaginative they consider themselves already to be, can increase the range of their fantasy conceptualization by deliberately walking into and exploring such playgrounds. The world of dreams is another. Allowing your mind to follow an initial idea as it runs its course—no matter how silly that course might seem to be—is yet another. You might read an interesting history book, a popular book on quantum physics, or your local newspaper, or go to an art gallery, a photographic exhibition, the movies, or the beach. Maybe you could try just playing around with a new artistic medium, watching what happens as you doodle. Any of these may offer open gateways into a playground of the imagination, or be the playground themselves.

The point is that you can discover or rediscover your imagination through consciously opening yourself to all sorts of influences. You should not expect those influences directly to affect your creative work—indeed, parroting them is something you need to guard against. What you are wanting them to do instead is to spark off new trains of ideas in your mind: you're wanting them to help you discover your own imagination.

Someone once said, "The trouble with having an open mind is that people come along and put things in it." As a fantasy creator, this is something you want to encourage people to do. Let the disparate notions clash or interconnect in your head—you can always sift out the junk later. In the meantime, allow yourself to wander at will through the playground of ideas that you have ingested.

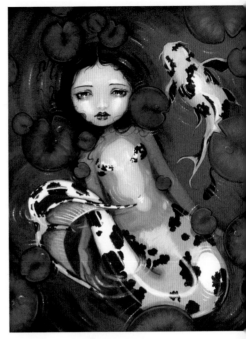

Koi Pond Mermaid
Jasmine Becket-Griffith uses the mermaid's tail to give movement to this image, echoed in the fish on the right. Her use of color throws the central figure forward out of the background.

1

Tools and Techniques

Kraken
Kieran Yanner

Pencil "leads" are made from graphite, a soft crystalline form of carbon, which is mixed with clay and fired in a kiln.

Pencils
and graphite

Pencils
Good-quality pencils have properly defined grades and even-grained wood casing.

The more graphite a pencil lead contains, the softer and blacker the mark, while a higher clay content makes the lead mark paler. The lead is encased in wood, usually cedar, which is marked on the side with a number and letter classification. "B" is for black, with more graphite; and "H" is for hard, with more clay. The higher the number the softer or harder the pencil, so the highest number, 9B, is extremely soft.

Graphite sticks are shaped like thick pencils without the covering of wood, and are also graded: 2B is a useful average. Some sticks are lacquered for clean use, so scrape them down if you wish to make broad marks, and wrap uncoated sticks in aluminum foil. Graded leads are made for some technical, or propelling, pencils. Office pencils are usually graded HB or B, and ones that make black marks can be used for drawing. Use a sharp craft knife to sharpen them.

Propelling pencils
These pencils are designed for technical use, and so make a standard-width mark.

Graphite sticks
These graphite sticks are coated in lacquer. Thicker, uncoated sticks give fast sideways use.

Ungraded pencils
Soft, black, ungraded pencils have large diameters and thick leads, and are useful for broader work.

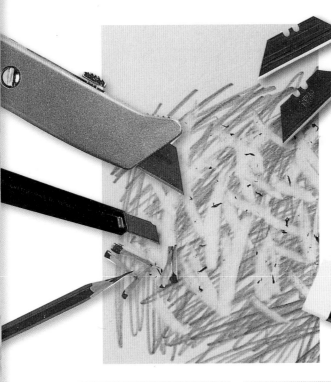

Erasers

The best erasers are the flexible, white plastic erasers that remove marks without abrading the paper.

PAPER STUMPS

You can soften pencil marks with a finger, but try a paper stump, or torchon, as fingers are slightly greasy. Small stumps are rolled with long points, and don't obscure your view. Larger stumps are double-ended.

SUITABLE BASE

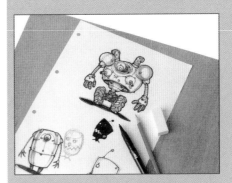

Choose a base that suits the weight of pressure you tend to apply with your pencil. Wood or plastic may be too hard, so try another surface such as card or thick paper.

Try out the different grades of pencil to see the effects and compare all the marks together.

Using pencils and graphite

Leave paper blank or erase tone for highlights.

A soft, dark mark reduces the silvery tone of a harder grade of pencil almost to insignificance when placed together. These different effects can broaden your creative horizons, but mixing grades may sometimes lead to problems with light and shade. Choose the right grade of pencil for your fantasy work and you will need only one—because the medium is so subtle and responsive.

Your first consideration should be the size of your drawing. Large fantasy artworks are usually viewed from a distance, and may lack impact unless a very soft grade is used—and still may not have the drama of charcoal (see page 18) which is ideal for large drawings. Soft pencils can be used for work of any size, but hard ones should be reserved for small drawings where the paler marks will be seen from close up. Time is another factor: because pencil is a linear medium it takes a while to build up density.

Cross-hatching darkens without looking uniform.

BUILDING UP TONE

Tone is built up using several methods that can be applied individually or together in the same work. Lines can be hatched or cross-hatched to achieve areas of varying density. Areas of tone can be scribbled and made darker or lighter depending on the amount of pressure applied. To blend tones into one another you can use a finger, a paper stump, or a soft eraser.

Cross-hatching builds tone and density in a controlled way.

Light pressure.

Firm pressure.

The heavier the pressure, the darker the tone.

Vary and lighten tone by blending.

Powerful figure drawing
Through dynamic use of line Liam Sharp creates a forceful image of Myrddin the Wizard.

Erasing

An eraser can be used to produce specific tonal or textual effects as well as corrections. It can also be used as a tool to lift out highlights.

Texture

A single soft pencil is capable of a wide visual vocabulary. A number of textural effects are possible, utilizing a variety of marks such as dots, dashes, short jabbed lines, loose scribbles, fast scribbles, fat lines, thin lines, dark lines, light lines, ticks, and squiggles.

Charcoal sticks can be messy to use, but if you don't mind dirty hands it is a very attractive medium for the fantasy artist.

Charcoal and conté

Charcoal sticks are made in varying lengths up to six inches and are usually graded according to diameter. The charcoal is also graded as soft, medium, or hard. Large rectangular blocks and thicker sticks known as "scene-painters' charcoal" are also available, and are ideal for working on large areas.

Charcoal is also very forgiving and easy to remove prior to fixing—a flick with a rag is all that is needed to remove most of the mark.

Compressed charcoal, sometimes known as Siberian charcoal, is made from powdered charcoal dust mixed with a binder and pressed into short sticks. These are substantially stronger than stick charcoal. Several manufacturers grade their sticks according to hardness: from the hardest (3H) to the softest (HB); and by blackness: from the blackest (4B) to the lightest (2B). Compressed charcoal sticks can also be found in a range of grays, which are made by mixing charcoal dust with binder and chalk.

Wooden charcoal pencils
These contain thin strips of compressed charcoal, and are found in grades of soft, medium, and hard.

Compressed charcoal sticks
These are available with both round and square profiles.

Charcoal is a messy medium, but you can keep your hands clean by wrapping foil around the stick.

To brush off charcoal or soften marks, before fixing, try a soft brush as an alternative to a rag.

To make oil charcoal, simply soak a stick of charcoal in linseed oil for a few hours—or, even better, overnight. Remove the charcoal, then wipe away any excess oil. Work as usual, and you will notice that the charcoal line will not smudge or need fixing.

Thicker charcoal sticks and compressed charcoal can be sharpened to a point with a sharp knife, a sandpaper block, or fine to medium sandpaper sheets. Use a knife for wooden charcoal pencils. Sometimes these are wrapped in paper, which is removed by pulling a thread of string on the side of the strip.

Conté pencils and sticks

These are available in a range of traditional colors: white, which is made from chalk; sanguine, which is made from iron oxide; bistre, a dark brown made by boiling the soot from burnt beech wood; sepia, which is obtained from the ink of the cuttlefish; and black, which is made from graphite.

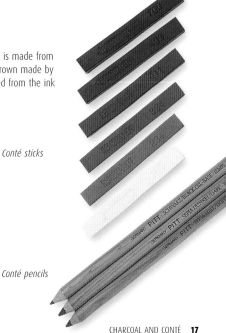

Conté sticks

Conté pencils

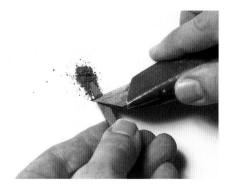

Conté sticks are sharpened using a sharp blade.

Charcoal is an expressive material ideal for fantasy art,
with fluid drawing movements and variations in pressure.

Using charcoal
and conté

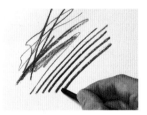

The characteristics of charcoal make it possible to produce fantasy drawings that contain a great variation of line. Both regular charcoal sticks and compressed charcoal sticks can be used by bringing the side or the end of the stick into contact with the surface you are working on.

Thin-stick charcoal produces strong, linear strokes.

The thickness of the stroke can be varied according to the angle at which the stick is held.

Thick marks can be made by using the charcoal on its side.

BUILDING UP DARKS

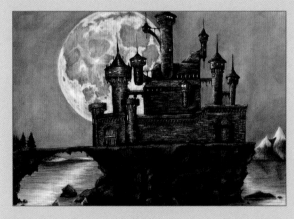

The versatility of charcoal is demonstrated in this expressive drawing in which Paul Bielaczyc has created a brooding nighttime scene with the dark mass of the castle filling the foreground. The intense blacks of the rock supporting the castle contrast with the precise line work of the fortified walls and towers.

CONTÉ

Conté pencils can be used in the same way as graphite pencils or any other line medium.

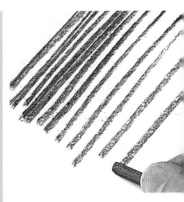

Used on its edge, a conté pencil makes thin strokes.

With a conté stick, striking, linear strokes can be made.

The shape of the pencil allows for lines of varying width.

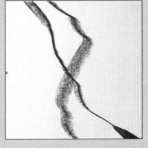

Altering the angle of the stick results in different line widths.

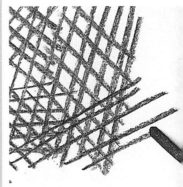

Hatching and cross-hatching

Areas of tone and texture can be built using a web of hatched (top) or cross-hatched (above) lines or marks. These lines or marks can be very precise and controlled or loose and random.

A blunter conté pencil will make a solid, wide mark.

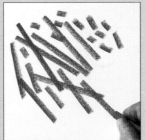

Try the unsharpened end of the conté stick to make a darker mark.

Tone

Areas of tone can be quickly scribbled or blocked in with wide strokes, using the edge of the stick, but to achieve a full range of tone blend with a finger, rag, paper stump, or brush.

Textural effects are easily achieved with charcoal, since it is such a responsive medium that every tremor of the hand results in a well-defined mark. It is also valued for its ability to bring out the grain and texture of all but the smoothest paper, and this quality can be incorporated into the effect sought after in your work.

When used on rough paper, charcoal shows off the texture of the surface.

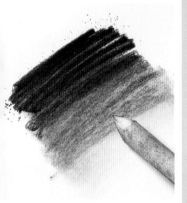

Here the charcoal is spread using a paper stump.

Constantly altering the direction of the mark results in a scumbled texture.

Irregular dots and dashes produced in varying densities suggest tone.

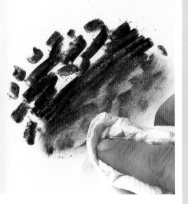

A finger wrapped in a paper towel makes a good blending tool.

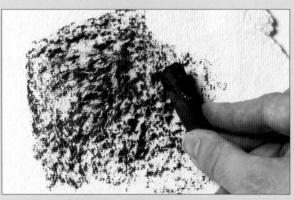

Used on its side, a thick stick of charcoal can cover a large area quickly and easily.

Erasing

Charcoal is particularly receptive to being worked into with various erasers. These will produce a variety of effects—from fine, crisp, sharp lines to texture and highlights.

A versatile medium

Charcoal and pastel are ideal mediums to combine. Here, with bold use of red pastel and charcoal, Paul Bielaczyc creates a striking fantasy scene that pulls on our imaginations and recalls strange tales of wolf-like creatures.

Using a soft eraser creates texture over a broad erased area.

Hard vinyl erasers can create thin, sharp lines when used in charcoal.

The fantasy artist working with colored pencils now has a wide range of high-quality materials to choose from.

Colored pencils

Every brand of pencils has its own handling qualities—the pencils are usually sold individually as well as in sets, so it is worth trying out a few different styles. There are variations of texture, and the colors available vary between brand-name products, so you should keep in mind the versatility of the palette if you decide to buy an expensive boxed set. The surface finish of the paper you use also significantly affects the pencil application. Some artists like a grainy paper with a rough tooth that breaks up the color; others prefer a smoothed-out finish that leaves all the textural qualities dependent on the way the marks are made. Ordinary drawing paper is fine for practicing your skills and is often used for finished work. But if you want to get a special effect, making use of the paper grain, check out the variety of papers sold primarily for watercolor and pastel work.

These are the essential ingredients and once you have chosen from the different types of pencils available, you will be ready to start.

Wax pencils in the softest grades
These create subtle effects of shading and color gradation.

Chalk pencils
These have a velvety, pliable texture ideal for blocking in and blending.

DIFFERENT APPROACHES

Colored pencil allows for an almost infinite range of styles, and strong use of hues. Below, the artist creates a dramatic scene, enhanced by his vivid use of color and energetic lines applied almost to sketchy effect. He both mixes colors on the surface and boldly sets contrasting hues alongside each other: the orange and purple, rendered in loose irregular lines, perfectly evoke the overwhelming sense of fire and smoke, as the diminutive figure takes on the dragon.

Water-soluble pencils
These can be used wet and dry, providing a high degree of textural variation.

Wax pencils of a slightly harder consistency
These are versatile for line work, hatching, and shading.

Hard pencils with fine leads
These are well suited to drawing intricate detail, and to the technique of impressing.

Although colored pencil is naturally a line medium, there are many ways of building up areas of solid and mixed color.

Using colored pencils

Hatching and cross-hatching are traditional methods of creating effects of continuous tone using linear marks. With a color medium, they can also enable the fantasy artist to integrate two or more hues and produce color changes within a given area.

Hatching simply consists of roughly parallel lines, which may be spaced closely or widely, and with even or irregular spacing. In monochrome drawing, the black lines and white spaces read from a distance as gray—a dark gray if the lines are thick and closely spaced, a pale shade if the hatching is finer and more open. The effect is similar with colored lines, the overall effect being an interaction between the lines and the paper color showing through.

Cross-hatching is an extension of hatching in which sets of lines are hatched one over another in different directions, producing a mesh-like or "basketwork" texture. Again, an area of dense cross-hatching can read as a continuous tone or color.

Simple but effective shading
This menacing robot has been modeled simply from shading and line. Alternating between light and heavier shading, the artist has followed the contour lines to evoke its bulk and metal shell, an effect that is enhanced by the paper's surface texture.

Hatching

The technique of hatching can be clean and systematic or free and variable. The lines can be of relatively equal weight and spacing (right) or may vary from thick to thin, with gradually increased or decreased spacing (far right).

Cross-hatching

The denser the cross-hatching, the more options for developing shading and color. Using different colors cross-hatched (right) adds tonal and color interest. Cross-hatching the same color creates an integrated network of lines (far right) that can be straight, curved, or directional.

FREE-HATCHING

The lines of hatching do not have to be distinct and separate. Here, the second layer of color is hatched over the first with a free scribbling motion.

VARYING THE TEXTURE

Different qualities of shading and texture are developed by varying line, weight, and spacing, and by combining colors. Lines that are converging, rather than parallel, suggest space.

Blending

There are various techniques for blending colored pencils effectively. The method you use will depend on whether you want to achieve smooth gradations of color and tone, a layered effect built up by overlaying colors, or an optical mixture created by massing linear pencil strokes to produce overall color blends, as with hatching or stippling.

Using solvent you can obtain effects closer to the fluid color blends typical of paint mediums, while burnishing heightens the effect of graded and overlaid colors. Experiment by dipping your colored pencils into different solvents so you can see their different surface qualities, and choose the method best suited to an individual work.

BLENDING USING CROSS-HATCHING

An alternative method of blending is to use the technique of cross-hatching. Apply a different color each time you change the direction of the set of hatched lines.

Blending with waxy pencils

Waxy-textured color does not spread easily, so you need to create a blend by working one color over another. When shading, keep the pencil strokes even and work them in the same direction in each color area (above).

By overlaying the colors, you create a third color that merges the hues of the first two. You can shade lightly (above, top), or rework the color layers until you fill the paper grain (above).

To blend flat color areas, begin by laying down areas of solid shading. Then, using the paper stump, gently soften the transition from one color into the next.

Subtle tones
Patricia Ann Lewis-MacDougall gives her picture a gentle, ephemeral quality by softly blending the colors.

Blending with chalky pencils

1 The texture of chalky pencils allows the colors to be blended by rubbing. Begin by working one color over another with loose hatching.

2 Use a paper stump (see page 13) to spread the color. Press it into the paper grain by rubbing gently but firmly over the pencil marks. Alternatively, you can rub with your fingertip or a cotton swab.

3 In this example, the blended colors show the direction of the original hatching, creating a soft but active surface effect.

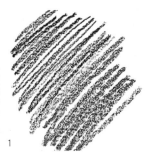

1

2

3

According to a Chinese saying, "in ink are all colors," highlighting the wide range of tonal possibilities within a single ink color.

Inks and pens

Ink is a wonderfully flexible medium that has been popular for centuries. It played a notable role in ancient Chinese art.

However, ink does not have to be black or monochrome as there are now many colored variants available. These are perhaps less widely used than traditional blue, black, and sepia inks, but they can add substantial interest to a fantasy drawing. They come in water-soluble and waterproof versions, and the latter can be used very much like watercolor and diluted with water to produce lighter tones. Acrylic inks can also be diluted with water, becoming waterproof when dry, and are made in a wide range of colors, which can be mixed together to achieve further variations.

Waterproof ink *is diluted with water.*

WATERPROOF INKS

Non-soluble when dry, these inks are made using soluble dyes in a shellac base. They are denser than the non-waterproof varieties, dry to a slightly gloss finish, and are suitable for very precise work. The inks have a tendency to clog easily, however, and brushes and pens must be cleaned thoroughly after use (do not use the ink in technical or fountain pens). Liquid acrylic inks are another type of waterproof ink. Unlike shellac-based inks, they are made from pigments rather than dyes and are thus lightfast.

Shellac-based inks *dry slightly glossy.*

NON-WATERPROOF INKS

Non-waterproof inks do not contain shellac. When dry, they will soften and dissolve if washed over with water. They sink into the paper more than their waterproof counterparts, and then dry to a matt finish. They are widely used for laying washes over waterproof-ink drawings.

Calligraphic inks

Non-waterproof inks

LIQUID ACRYLIC INKS AND LIQUID WATERCOLOR

Liquid acrylic inks are completely waterproof when dry, and most standard colors are lightfast. They are used in the same way as shellac-based waterproof inks, but cannot be mixed with them.

Liquid concentrated watercolor is available in many colors but, like ordinary watercolors, may fade if subjected to bright light.

Liquid acrylic inks

Liquid watercolor

Chinese inks

Dip pens and nibs

Dip pens that take interchangeable nibs are made from both wood and plastic. Shapes and sizes vary, so test a few until you find one that is comfortable to use. A wide range of nib shapes and sizes is available; not all fit into every dip pen, however, so make sure that your choice of nib will fit your pen. Nibs are made for specific purposes, but all nibs can be used for drawing, and several different nibs may be used during the course of a single work. If the nib seems reluctant to accept the ink, rub a little saliva onto it. A flexible nib allows for a range of line thickness and quality; simply vary the pressure you apply to it.

Bamboo and reed pens

Bamboo pens are cut from a short length of bamboo. They vary in thickness, and some are shaped so that they have a different-sized nib at each end. The nib makes a line of a consistent thickness with an irregular, coarse texture, which lends itself to bold approaches.

Reed pens have a far more flexible nib than bamboo, and can be easily re-cut and shaped using a sharp knife.

The fantasy artist can turn to an extensive range of marker, ink, and fiber-tip pens, which are available in a wide choice of colors.

Markers, pens, and fiber tips

The only immediate drawback of marker, ink, and fiber-tip pens is that they may fade over a period of time. However, they are excellent for planning and preliminary work, and for drawings that won't be exposed to the light, such as sketchbook studies.

Markers are divided into water-based and solvent-based varieties, and both are available with different-shaped nibs, such as wedge-shaped, chisel-shaped, or pointed. Different brands of markers can be mixed with one another to produce a surprising range of interesting effects and color combinations. Pens are also available in a wide range of colors and with varied nibs that can provide opportunities for striking line and color work.

Drawing pens and ink cartridges

Calligraphic fountain pen

Rollerball pens

BRUSH PENS

Brush pens have flexible, brush-like nylon tips that make fluid calligraphic strokes as opposed to the wedge-shaped marks produced by most markers. Many brush pen brands also have a fine-liner tip at the other end of the pen. The pens can be used with traditional markers.

SOLVENT-BASED PENS AND MARKERS

Until recently, the only marker and fiber-tip pens that offered any degree of permanence were solvent-based, a problem for anyone susceptible to the adverse effects of solvents, but following a great deal of research the available range of non-solvent-based pens and markers has become much greater.

ART PENS AND FOUNTAIN PENS

Art pens resemble traditional fountain pens, and hold cartridges that deliver a steady flow of ink to the nib. They are available with nibs of different sizes and shapes, giving a range of line thickness.

BALLPOINT AND ROLLERBALL PENS

The range of ballpoint and rollerball pens to choose from is huge, and they make very useful drawing tools. Although only available in a limited nib size, they can be found in an ever-growing range of colors. Rollerballs tend to be slightly "wetter" than ballpoints, and seem to deliver more ink. Both types of pens last a long time.

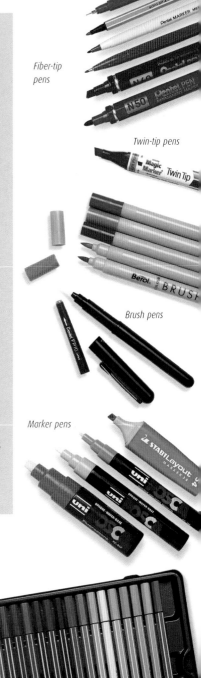

Fiber-tip pens

Twin-tip pens

Brush pens

Marker pens

Ballpoint pens

Fiber-tip pen set

Working with ink has been likened to a trapeze artist working without a safety net, because any mistakes are difficult, if not impossible, to rectify.

Using inks
and markers

As a medium, ink demands concentration and a decisive hand, but once you have mastered it, you will find it is one of the most spontaneous and exciting mediums available for your fantasy art.

When starting to draw in ink, try to make your marks and lines as confidently as you can, even if this means throwing away a drawing and starting again. In this way, you will begin to learn the technical aspects of the medium; for example, it is vital to know when to reload a pen or brush in order to achieve a flowing unbroken line, and this knowledge can only come through experience. You will probably get through a lot of paper, but the immediacy and straightforwardness of a good ink work makes the effort and expenditure worthwhile. One tip for beginners is to make a light drawing in soft pencil or charcoal as a guide for the pen work, and another is to practice making the line on a spare piece of paper before making it on the actual drawing.

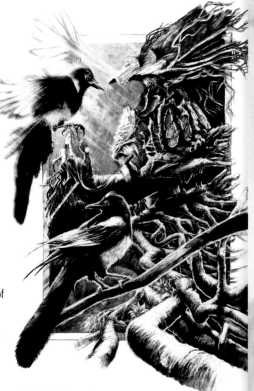

Confident ink work
Mike Nash has vividly created an ominous scene, with the heavy ink enhancing the mood and depth.

DIP PEN

The dip pen's capacity to accept a wide range of nibs makes it extremely versatile.

ART PEN

Art pens are quick and clean to use, making them ideal for sketching.

MARKER PEN

With the different shapes and sizes of these versatile pens, you can produce a wide variety of marks.

BAMBOO PEN

A bamboo pen needs plenty of ink; it can feel dry and stiff as it moves over the paper surface.

TECHNICAL PEN

The line made by this pen is of uniform width, with the paper lying on a smooth surface.

BRUSH PEN

Brush-pen marks vary in thickness, according to the pressure applied.

QUILL

The natural feather quill makes a range of unique marks.

BALLPOINT PEN

Ballpoint and biro pens produce lines of uniform width.

ORIENTAL BRUSH

This type of brush, made specifically for drawing with ink, creates very expressive marks.

PEN LINE

The flexibility of the dip pen results in expressive lines in an extensive variety of widths.

WASH

Pen line coupled with a brush wash is a classic combination of techniques.

Building tone

Water-soluble inks can produce a wide range of tones according to the amount of water used to dilute them.

Hatching and cross-hatching are the traditional methods of building up tone in a pen and ink drawing.

Line and tone
Pen and ink wash, as in this sketch of a robot, is ideal to render shape and metallic material.

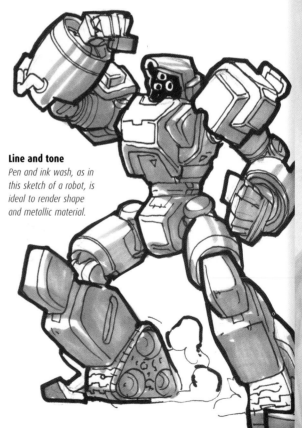

Special effects

Various textures and effects can be created with inks. Here are just a few.

Dry sponging
A dry sponge can be used to lift ink laid on wet paper to create subtle color and tone changes.

Marker pens

Depth of color can be built up by layering marker color, working from light to dark as with watercolor.

Blending pens

These contain a solvent, and are produced for the purpose of mixing marker colors on the paper surface.

Wet sponging
Sponges can also be used to apply ink, creating random textures.

Brush and ink

Inks can be applied with brushes as well as pens (see page 30). Here, an oriental brush is used. Such brushes are held differently to western ones, at right angles to the paper, and the hand does not rest on the work—the movement comes from the whole arm, not just the wrist. This allows for fluid line work, but requires practice.

Scratching
Here, ink has been laid over scratched paper, which provides a rough texture, and then rubbed with the side of a colored pencil to bring out the marks.

TEXTURE

To create texture, ink can be spattered or dabbed on with a sponge, rag, or finger. Coarse fabric can also be used to make imprints, as can leaves, feathers, or anything else with a texture of its own.
 Try using watercolor-resist techniques with a wax candle or spirit solvent, or try masking techniques using liquid frisket (see page 39).

A clear wax candle is used to draw the design, and then is washed over with diluted ink.

Lifting-out
Removing color with a tissue or dabbing the paint when still wet can create soft highlights or interesting effects.

Watercolor paints are sold in tubes, pans and half-pans, with both of the latter designed to fit into a paintbox.

Watercolor
choices

You can buy paintboxes complete with around 12 colors—or sometimes fewer—but some people prefer to choose their own colors, as this allows you to start with a smaller range and build up gradually.

Whether you choose pans or tubes depends on your fantasy style and subject matter. For small paintings, perhaps partly done on location, pans are more convenient as the paintboxes have wells for mixing paint, and you can simply fold up the box on completion. Tubes necessitate a separate palette which can get messy and require cleaning. For any large-scale paintings, tubes are best as you can mix large quantities and strong colors more easily.

Paintboxes

Half-pans are more easily available than whole pans, and most of the ready-made paintboxes on offer will contain the smaller size. These can be replaced when finished, as all the colors may be purchased separately.

Buy the best

Tubes of watercolor are made in a standard size, which may look small in comparison with tubes of oil or acrylic but actually last a very long time. Look for the label "artists' watercolor," and don't be tempted to buy the less expensive paints, known as students' colors, as these contain less pure pigment and may lead to disappointment. This advice also applies to pans of paint.

Brushes

Most people will know that the best brushes to use for watercolor work are sables. There is no argument about this, but sables are expensive, and there are many excellent synthetic brushes and sable and synthetic mixtures which are quite adequate for most purposes.

A good brush should have a certain resilience. You can test the spring of your brush by wetting it into a point and dragging it lightly over your thumbnail. It should spring back, not droop. You also need brushes that hold a good quantity of water—you can test this easily by moistening it with your mouth. Don't try this with a paint-loaded brush however, as trace elements from the paint can be retained in the body.

Brush sizes

Remember that the larger the brush head, the more paint it will hold, so make sure you have a choice of brush sizes for different applications. However, don't go overboard and buy a whole range—one large, one medium and one small are all that is needed, and some artists use only one brush.

Brush sizes, from bottom to top: size 00 round, size 0 round, size 1 round, size 3 round, size 5 round, size 10 round, and size 12 round.

Chinese brushes

If you can only afford a few brushes, Chinese brushes are a wise choice, as they can create a wide variety of different marks and are much less expensive than sable brushes. They are becoming very popular with artists, especially those who like to exploit the marks of the brush in their work.

STRAIGHT LINES

Although long, straight lines can be made using the point of a round brush, for a variety try a "writer" or a "striper," which were traditionally used for this role. Writers are long-haired sables that taper to a point. They are also called "riggers," as they were used to paint the rigging on ships. Stripers are long-haired sables which form a chisel edge.

Medium rigger

Large rigger

Shaped rigger

BROAD LINES

One-stroke brushes, commonly made from synthetic or ox hair, are good for creating broad lines. Short flats and long flats can also be used. They are all chisel-edged and held in flat ferrules. Short flats are especially suitable for applying short dabs of color, while long flats hold enough paint for you to make one stroke across your paper.

Small flat

Medium long-haired flat

Large long-haired flat

Small long-haired flat

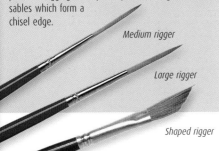

37

Lines and washes

This World War II robot, Elektrograd, is given a battle-worn nostalgic feel through the fine outline and the variegated washes of blue watercolor, in which the darker areas are built up through additional coats of wash. The red and yellow wires and buttons are applied with the tip of a round brush.

TESTING BRUSHES

The better the quality of brushes, the better your brushmarks will be, so check the quality of any round or pointed brush by painting a fine line with it. The point of a good brush should give a fine line, whatever its size.

A good-quality rounded brush will give an equally clean line, but a poor-quality one will quickly fail the test.

With a pointed brush, the line created is sensitive and delicate, and can be varied from thick to thin by lessening the pressure.

Brush care

At the end of a working session, stand your clean brushes upright in a jar or other container. Never place them downward or you will ruin the bristles. If you are transporting your materials you may find one of the special cylindrical plastic brush holders useful, but make sure the tips of the brushes don't come into contact with the lid as this will bend them.

Water

Clean water is a vital ingredient in producing a good fantasy painting, as you will quickly discover if your water becomes dirty. Always have three pots of water ready when you paint: one of clean water for loading brushes and wetting the paper; one of constantly replaced clean water for mixing with the paint to produce clean, clear colors; and one for rinsing brushes while you work.

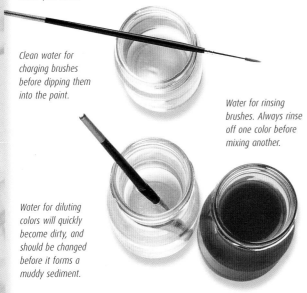

Clean water for charging brushes before dipping them into the paint.

Water for rinsing brushes. Always rinse off one color before mixing another.

Water for diluting colors will quickly become dirty, and should be changed before it forms a muddy sediment.

Other equipment

A small, natural sponge forms part of most watercolorists' kits. It can be used to wash off paint when a mistake has been made, to soften edges, and to lay washes and lift-out (see page 41). Another standard item of equipment for many artists is liquid frisket, masking fluid with which you can "reserve" highlights by applying the fluid before painting. Finally, you will need pencils for underdrawing (see pages 12–13), boards for supporting the paper, and last but not least, receptacles for holding water.

Palettes

Watercolor paintboxes containing pans of color incorporate their own palettes, but these do not always provide enough space for mixing, so you may need an auxiliary palette. If you use tubes rather than pans, you will need a palette with recesses to squeeze the colors into and shallow "wells" to keep the mixed colors separate. There is a wide choice of such palettes, made in both china and plastic, and you can also buy small, circular-dish palettes that can be stacked when not in use.

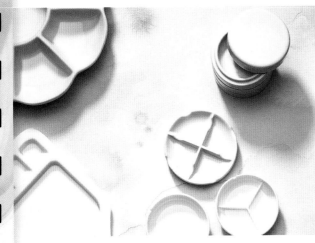

You don't need a large selection of colors initially, as it is best to practice mixing from a small range to discover which colors can be mixed most satisfactorily.

Using watercolors

The fantasy artist's first requirement is at least two of each of the primary colors—red, yellow and blue—as these are made in different versions. Lemon yellow, for example, is more acid and "cooler" than cadmium yellow; cadmium red is a brilliant pure hue while alizarin crimson tends slightly toward blue; ultramarine is a strong "warm" blue, while both cerulean blue and Winsor blue are cooler and slightly more green. You can make a start with just these six colors, but it is useful to have at least one green and a few browns as well. The 12 colors shown here should be adequate for most subjects.

BASIC PALETTE

This palette comprises eight primary colors, one secondary (green), and three tertiary (two browns and one gray). You could add another green, such as sap green, and perhaps another brown—raw umber would be a good choice. You also might find that cerulean blue is not essential at first, although it is ideal for painting skies.

1 Cadmium red. Primary
2 Alizarin crimson. Primary
3 Lemon yellow. Primary
4 Cadmium yellow. Primary
5 Yellow ocher. Primary
6 Burnt sienna. Tertiary
7 Burnt umber. Tertiary
8 Viridian. Secondary
9 Cobalt blue. Primary
10 Cerulean blue. Primary
11 Winsor blue (also known as phthalo blue). Primary
12 Payne's gray. Tertiary

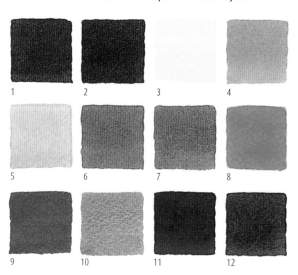

Techniques

Watercolor techniques could fill an entire book on their own; there is only enough space here to deal with the basics. Many of the methods, such as wet-on-wet and lifting-out, are the same as those shown for inks on page 35, but do remember that watercolor remains soluble even when dry, so too many layers can stir up the colors beneath and result in a muddy effect.

Creating other worlds

Watercolor lends itself perfectly to Alan F. Beck's fairy-tale image of the dragon and her three chicks gazing into a vision of their future. The background is in the style of Chinese painting, giving an atmospheric setting to the magical creatures.

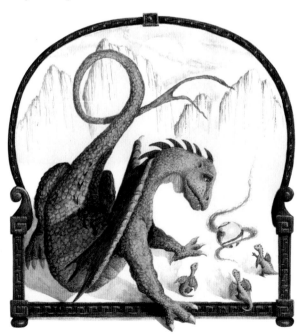

Granulation

Unlike inks, some watercolor pigments do not fully dissolve in water, creating a grainy texture that may be useful.

Blotting with a brush

By blotting out spattered areas of paint with a brush, an interesting outline effect can be achieved.

Impressing

A good natural texture effect can be obtained by pressing several tissues hard on a partially dried area of color.

Cloudy effects

Amorphous shapes can be created by brushing on an area of flat color, leaving it to dry, and then going over it with clean water before dabbing off paint.

Controlled wet-on-wet

To achieve soft color transitions within a controlled area, lay a color and then drop in more paint while still wet as it will not spread onto the dry paper.

Fine spattering

For a fine, easily controlled spray, a toothbrush is the best tool. Load it with paint and then drag a paintbrush or ruler over the bristles.

Fantasy artists will find acrylic paints highly versatile since they are a by-product of the plastic industry, like the paint on our walls.

Acrylic paints

The pigments used for acrylics, with a few exceptions, are the same as those used for oils, watercolors, and pastels; what makes them different is the binder, which is a polymer resin. This, once dry, acts as a form of plastic coating that cannot be removed.

Because the paints are water-based, they are thinned by mixing with water or with a combination of water and one of the many mediums specially made for the purpose. With acrylics, you can paint in any consistency you like, making them amazingly versatile and ideal for fantasy painting. You can use them in thin washes resembling watercolor, or apply colors with a knife in thick slabs. You can use thick paint in one part of a picture and thin in another; you can build up an infinite variety of textures; and you can employ traditional oil-painting methods such as glazing, which is much easier in acrylic than in oil.

Painting sets

Several manufacturers offer introductory sets that include a range of preselected colors and, occasionally, different acrylic mediums, brushes, and palettes—all contained in either simple packaging or a tailor-made wooden box. These sets can be an expensive way to sample acrylics, and also the colors may not be to your liking, so it is usually better to purchase a few tubes and brushes separately.

Tubes and pots

Some manufacturers offer tubes in two or three sizes, with an extra large one (125 ml) for white, which is used up quickly. The smaller size (22 ml) is an economical choice for expensive colors that you don't use very often.

Pots, which are usually slightly more fluid than tubed paints, are useful for large-scale studio work. Avoid dipping the brush directly into the paint, as you will pollute the color if the brush is not perfectly clean.

STUDENTS' COLORS

Acrylics, like most other paints, are produced in two versions: students' and artists'. The former contain less pure pigment to the proportion of filler, making some of the colors less intense, and the range of colors is smaller than the artists' colors. However, most are of good quality, and being less expensive than artists' colors can be ideal as an introduction to the medium.

ARTISTS' COLORS

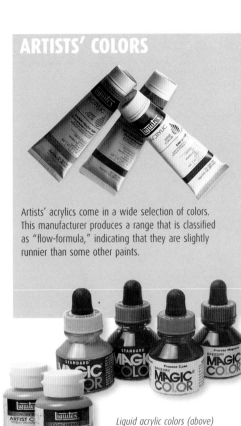

Artists' acrylics come in a wide selection of colors. This manufacturer produces a range that is classified as "flow-formula," indicating that they are slightly runnier than some other paints.

Liquid acrylics

Liquid-acrylic color is slightly more expensive than tube acrylics and resembles ink or liquid watercolor. It is available in bottles, and most bottle tops contain a dropper for transferring paint onto the palette. Liquid acrylics can be used in much the same way as ink and watercolor. Since they are made with an alkali resin, you will need to use preparatory alkali cleaning fluid to soften and remove the paint from pens and brushes.

Liquid acrylic colors (above)
Medium-viscosity acrylic colors (left)

Chroma color

Chroma color is a water-based paint, originally developed for coloring cartoon cells. The colors are vibrant and strong. Made with acrylic resin, the paint can be used in a similar way to watercolor, gouache, ink, and, of course, acrylic itself. Chroma color is fast-drying, waterproof when dry, and can be massively diluted without losing its strength of color. It can be mixed with special Chroma mediums to retard drying time and add thickness, gloss, or transparency (use of non-Chroma mediums is not advised). It is available in 80 different hues, packaged in 50 ml tubes and bottles.

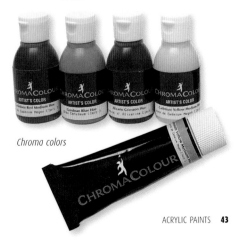

Chroma colors

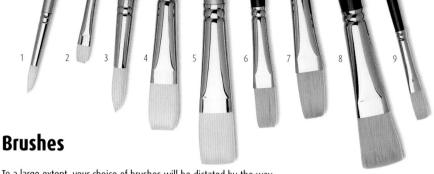

| 1 | 2 | 3 | 4 | 5 | 6 | 7 | 8 | 9 |

Brushes

To a large extent, your choice of brushes will be dictated by the way you work as a fantasy artist—whether you apply the paint thickly or build it up in thin layers. For thick applications and impasto work (see page 47), the bristle brushes made for oil painting are the best choice; while if you paint in a similar style to watercolor (see page 41) or with thin glazes, you would use soft watercolor brushes.

Probably the best all-round brushes are those that are made specifically for acrylic painting, since they are versatile in combining the characteristics of both oil and watercolor brushes and can be used for medium to thick applications.

Types of brushes

Nylon brushes are made especially for acrylic work. They come in the standard brush shapes and a wide range of sizes, and are tough, hard-wearing, and springy.

1 Small round nylon
2 Small flat nylon
3 Medium round nylon
4 Medium flat nylon
5 Large flat nylon

Bristle brushes, which are often made from hogs' hair, are the usual choice of fantasy artists who like to create oil-painterly effects.

6 Medium bristle
7 Medium-large bristle
8 Large bristle
9 Small bristle

BRUSH CARE

Because acrylic dries so fast, brushes must be kept wet throughout the working process, but don't leave them upside down in a jar of water for long periods, as this will splay the bristles. Stay-wet palettes (opposite) have a special compartment for brushes, but if you don't have one of these, place the brushes flat in a shallow dish.

Brushes can become clogged with paint from the tip to the ferrule. Before placing in water, remove the excess paint with a palette knife.

After each working session, rinse the brush in warm water and then clean it by rubbing the bristles into the palm of a soapy hand.

Palettes

Palettes for acrylic work must be made of a non-porous material such as plastic or glass, so don't try using the wooden palettes made for oil painting. Artists who work on a large scale often use sheets of glass, which can be easily cleaned, but if you do this, use heavy glass and tape the edges to prevent cuts. Pieces of laminated board can also be used, but they will become stained.

To prevent the paint from drying out, you can spray with water at regular intervals or use one of the special palettes designed for acrylic paint. They are made in two sizes, and are ideal for medium-thick paint applications, where you don't need to lay out large quantities of paint. They also have a compartment for brushes, which you fill with water.

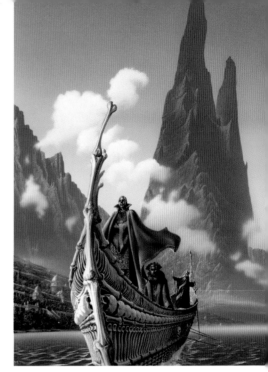

Stay-wet palettes

These palettes have been developed especially for acrylic, and can keep the paint wet for several days, or even weeks. They come in the form of a shallow tray with a clear lid, and with a packet of two different types of paper. The absorbent paper is placed in the bottom of the tray and well wetted; the membrane paper goes on top. The paint is laid out on the top sheet, and water seeps up to keep it moist.

Evoking strange worlds
Through his use of strong color combined with the smooth application of paint, Mark Harrison creates a beautiful yet macabre world.

Tear-off palettes

You can buy disposable paper palettes, which you simply throw away after use, or you can use an old telephone directory, removing each sheet when it has become filled with paint.

Acrylic paint can behave in similar ways to watercolor and oil paint in your fantasy paintings, but don't think of it as a poor version of either.

Using acrylics

Acrylic is an important medium in its own right, and a range of techniques has been developed for both thick and thin applications.

Although flat and graded acrylic washes are made in exactly the same way as watercolor washes, and worked dark over light, they allow for more layers and more variations in the paint consistency than watercolor. Once the paint is dry, it is stable so there is no danger that overpainted washes will disturb or move previous washes. Therefore when using transparent methods, don't try to imitate watercolor since it is pointless. Instead, discover how to exploit the possibilities of acrylic for its own unique effects.

In contrast, when used straight from the tube acrylic paint has a buttery consistency. It can be moved and manipulated easily by brush or knife, and its character can be altered by the addition of various acrylic mediums. Paint of this consistency is perfect for direct approaches, with even relatively thick paint drying within the hour. Gel medium can be added to preserve brush and textural marks. Blending, scumbling, and broken-color techniques all work well with paint of this consistency. For impasto work, use tube acrylic paint extended with a heavy gel medium, or with a texture medium or paste. Alternatively, you can create your own texture medium using additives like clean sand or sawdust.

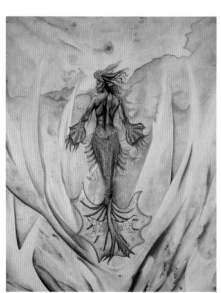

A versatile paint
Tina Renae demonstrates the versatility of acrylic through the loose handling of the sea, the modeling of the mermaid's torso, and the decorative treatment of the fin.

Using thick paint

Thin wash
Dilution with water or flow medium gives a transparent wash.

Granulation
As in watercolor, when water is applied some colors granulate.

Direct painting
Acrylic paint of a buttery consistency is perfect for rapid applications.

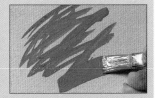

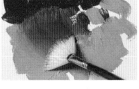

Graded wash
Adding water to the mix after each stroke creates a graded wash.

Adding white
The addition of white to the thin paint gives it a gouache-like quality.

Blending
Acrylic paint must be blended quite quickly, before it begins to dry.

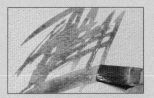

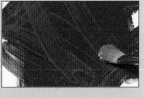

Dark over light
The application of dark paint over dry, light paint results in a watercolor-like effect.

Glazing
Acrylic paint is excellent for glazing techniques; its quick-drying capacity enables the completion of a painting in one sitting. Use of transparent colors and a gloss medium will further increase the colors' brilliance and transparency. Complex color transitions can be built up effectively and easily.

Broken color
Areas of broken color can be built up relatively easily, since the paint dries very quickly.

Scumbling
In this technique, a layer of wet paint is brushed over a dry, textured layer.

While alternative mediums have become more commonly used than oil in fantasy art, oil is still a rewarding paint to work with.

Oil paints

As with watercolor and acrylic, oil is available in artists' and students' colors, and there is no reason why you should not begin with students' colors to get the feel of the paint, but as you become more experienced as a fantasy artist, you should consider moving up the scale to artists' quality, as the colors are purer and brighter. They also have more tinting power than the cheaper paints, which contain less pigment and are bulked out with thinners, so you will end up using less of them.

Start off with a small range of colors and avoid buying a boxed set of paints, as these often contain colors you may never use. All oil paints can be purchased individually in standard-sized tubes, so you can add more as needed.

Paint boxes

Wooden paint boxes can be purchased without the paints, so that you can buy your own selection. They are made with special trays for the paints and mediums, a long slot at the front for the brushes, and a palette that fits into the lid. Paint boxes like this are not essential, as some of the heavy plastic boxes made for home improvement tools also make a good alternative.

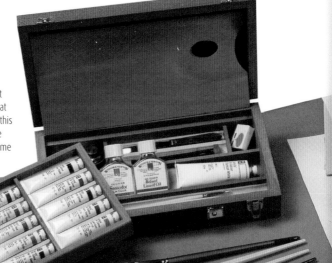

Brushes

Bristle brushes (usually made of hogs' hair) are specifically designed for oil painting. They have long handles, unlike the brushes sold for watercolor, allowing you to stand away from the painting surface, and are made in a variety of shapes and sizes. The three main shapes are flats, rounds, and filberts, all of which make distinctive marks, as shown below. Most artists also have one or two small round sable or sable-substitute brushes, which are useful for preliminary drawings and adding fine detail in the final stages of your fantasy painting.

You don't have to use bristle brushes if they don't suit your painting style, however. They are ideal for work in which the marks of the brush play an important part, but some artists like smoother effects, and prefer the nylon brushes made for acrylic. Therefore start with a small range of brushes until you discover which suit you best.

Using a knife

A palette knife, made for cleaning up the palette and mixing large quantities of paint, is an essential tool in your kit. Applying paint with a knife gives a very different effect to that of brushwork. The paint is squashed onto the surface, mixing into the color below to create a streaky, ridged effect.

TYPES OF BRUSH

Rounds
(Shown right: two sable and two bristle.)
• Rounds, when held vertically, are ideal for stippling. They can also deliver long, continuous strokes. Sable rounds taper to a fine point, and are useful for adding details in the final stages of a painting.

Flats
(Shown right: one soft-haired (synthetic) and three bristle.)
• Flats make distinctive square or rectangular marks, much exploited by Cézanne.

Filberts
(Shown right: one soft-haired (synthetic) and two bristle.)
• The hairs are quite long, arranged as a flat head and tapered to a rounded tip. Filberts are very versatile brushes. They can leave rounded dabs of paint or be twisted during a stroke to create marks of varying thickness.

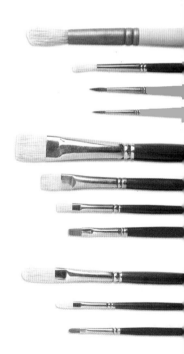

You can apply oil paint straight from the tube to your fantasy art, but it is usual to mix it with a painting medium.

Using oil paints

Thinned paint

These swatches show, from top to bottom: paint mixed with an impasto medium, paint mixed with linseed oil, and paint thinned with turpentine.

The two commonest mediums are linseed oil (also used in the manufacture of paint) and turpentine. The latter thins the paint as well as making it dry faster, and is normally used in the early stages of a painting, before being mixed with greater quantities of oil as the work progresses. Mineral spirit is sometimes thought to be an alternative, but is not recommended as it has no oil content and makes the paint look very dull; so save this for its main task of washing brushes. For those who are allergic to turpentine or dislike its strong smell, special odorless and non-toxic thinners provide an alternative.

There are many other mediums sold for bulking out the paint for impasto work, making it more transparent for glazing methods, and varnishing when the painting is complete and fully dry. With all of these, read the manufacturer's instructions carefully before using.

Mixing mediums

Paint mediums can be mixed easily and quickly. Recipes usually quote quantities in parts, and the easiest way to mix them is to use a jar or bottle with a tight-fitting lid and pour in the correct amount of each ingredient in turn, marking the level on the outside of the bottle after each addition.

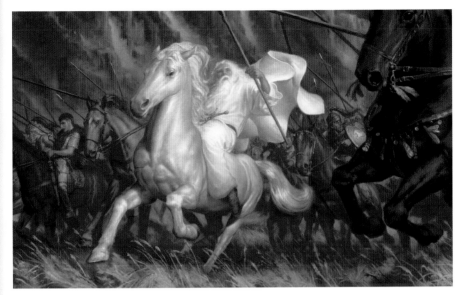

Heroic fantasy
Donato Giancola uses oil paint to dramatic effect in this battle scene: the wizard Gandalf and his horse "jump" out as the smooth brushwork and gleaming white paint contrast with the treatment of the background.

Cadmium yellow

Cadmium red

Ultramarine

Lemon yellow

Alizarin crimson

Cerulean blue

Titanium white

Viridian

Yellow ocher

A basic palette

You will need two versions of each of the primary colors—red, blue, and yellow—because even these vary in hue. As you can see from the swatches here, there is a "warm" and a "cool" version of each one, and this "color temperature" affects the kind of mixtures you make. Six primaries, a green, and one or two earth colors such as yellow ocher, raw sienna, burnt sienna, and raw umber—and white, of course—will enable a wide range of mixtures.

The fantasy artist's choice of paper is important because the surface texture will have a strong influence on the finished effect.

Drawing papers

The most commonly used paper for pencil and colored-pencil fantasy drawings is "cartridge" or drawing paper, which has a smooth surface, but some artists prefer to work on a more heavily textured paper such as those made for watercolor and pastel. If pastel is your chosen medium, you will have to work on textured paper because the powdery pigment will simply fall off if there is no "tooth" to hold it.

All papers are sold in loose sheets of various sizes as well as in sketchbooks in both landscape and portrait formats. Ultimately the choice of surface depends on the kind of work you intend to do.

1 Small- or medium-sized sketchbooks can travel with you in a bag or pocket.
2 A large sheet of handmade heavyweight (hot-pressed) paper.
3 Rough paper with a pronounced tooth and cream tint.
4 A specially created hammered effect in rough white paper.
5 Heavy, hot-pressed paper in an off-white shade.
6–8 Medium weight, hot-pressed papers in cream, green, and gray.
9–10 Lightweight, mold-made Ingres papers for pastel work in beige and blue-gray.

11–14 Lightly sized, absorbent heavyweights in green, cream, and two tones of buff.
15 Brightly colored papers for when you want to influence the overall warmth or coolness of your color scheme, or to create a base to shine through pencil or pastel.

15

14
13
12
11
10
9
8
7
6
5
4
3
2
1

Neutral tints

Neutral tints such as beige, buff, and gray provide a mid-toned background that enables you to key your range of pastel tones and colors. These can give the pastel rendering a cool cast, for instance blue-gray, or a basic warm tone, as with an orangey-buff paper.

Bright colors

Colors that are bright or very densely saturated make a strong impact on the overall image, intensifying the hue and texture of the pastel or pencil marks.

The influence of colored papers

A colored background is traditionally used in pastel work (and light tints are also sometimes used for colored-pencil drawings). Because the grainy texture of pastel usually allows the color of the support to show through, it is not always appropriate that this color should be white. You can use a colored ground to set an overall tonal value for your work—dark, medium, or light—or to give it a color bias in terms of warm (beige, buff, brown) or cool (gray, blue, green) color. It can also stand in for a dominant color in the subject—perhaps blue, green, or terracotta for a fantasy landscape, for example. Traditional artists typically select subtle hues but you may choose a strong color to isolate your image and throw it into relief.

For watercolor, there is a bewildering variety of handmade papers but most fantasy artists use the widely available machine-made ones.

Watercolor
papers

Machine-made papers are the best to start with; you can experiment with more exotic papers later if you wish. They come in different surfaces, of which there are three main categories: Smooth (otherwise known as hot-pressed or HP for short); Medium (sometimes called cold-pressed, CP, or Not, for not hot-pressed); and Rough (also cold-pressed, but with a much more pronounced texture). Although some artists choose smooth or rough paper for special effects, the all-round favorite is Not, which has enough texture to hold the paint but not enough to interfere with color and detail.

If you want to experiment with textures and effects on watercolor paper, use a good, heavy paper or watercolor board, which will take real punishment and not need stretching. It should soak up a lot of water without disintegrating.

Types of paper

1 Handmade paper
2 Extra rough mold-made artists' board
3 Cold-pressed (Not) paper
4 Rough machine-made paper
5 Hot-pressed (smooth) machine-made paper
6 Rough paper

Experiment with watercolor washes on different paper textures to discover the effects.

Watercolor papers are made in different weights, with the heavier ones being more expensive. Weights of paper are expressed as lbs per ream: the thickest ones are about 200 lb (425 gsm) and the thinner ones below 100 (219 gsm). Most sketchbooks contain paper of 140 lb (300 gsm). Thinner watercolor papers (including 140 lb papers if you use a lot of water) need to be stretched so that they don't buckle when paint is applied. This is easy, but has to be done well in advance of painting, as the wet paper takes time to dry. It is worth doing, however, as trying to lay washes on buckled paper is very frustrating. You will also save money, as the price difference between thick and thin paper is considerable.

1 *Sponging the painting side of the paper can stir up the surface. To avoid this, smooth some dry paper towels and position the paper, painting side down, on top.*

2 *Lightly sponge the back of the paper. The towels will absorb any residual water that seeps through to the top side. When finished, turn over the paper and remove the towels.*

3 *Tape down the paper with gummed-paper tape and leave it to dry. To speed drying, use a hairdryer but don't hold it near the surface.*

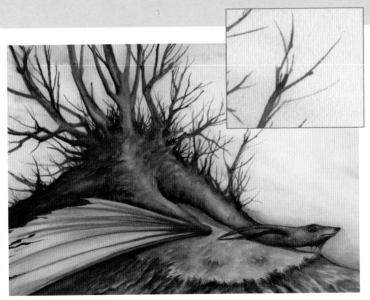

Mood and depth

Watercolor is often associated with realistic landscape paintings, yet it can be used to create a strong sense of mood as in Marc Potts's work. Here, with a limited range of color on paper with a very subtle texture, he creates an image that depicts more than first meets the eye.

There is a wide range of supports suitable for fantasy artists painting in acrylic and oil, so try out a few to find the right one for you.

Acrylic and oil painting surfaces

Canvas is the most widely used support for oil. It provides a sympathetic working surface, is light and easy to carry, and can be removed from stretchers and stored. However, there are many alternatives. Prepared painting board is popular. It has a slightly greasy feel and does not hold the paint well, but some manufacturers produce a canvas board that is fabric stuck onto board. Masonite is a useful support too, and for texture you can stick canvas (or old sheets and pieces of cheesecloth) onto it with wallpaper glue or acrylic medium. Both paper and cardboard can be used provided they are first sealed with a primer. You can paint on unprimed paper, but the oil will sink in to give a matt surface. Some artists like this effect, and Edgar Degas, who disliked the oiliness of oil paint, habitually worked on unprimed paper or board.

Canvas and board

1 *Canvas board*
2 *Double-sided art board: toned side*
3 *Double-sided art board: white side*
4 *Hardboard: rough side*
5 *Hardboard: smooth side*
6 *Stretched canvas*

Shown here (left) is a selection of painting supports. The one you favor will depend on the particular surface quality you like, such as "tooth" and springiness, so you may need to try out several before deciding which one suits your working method. Ready-stretched canvases are expensive, but you can stretch and prepare your own as shown opposite.

If you like to work on canvas but find the ready-stretched ones too expensive, you should consider stretching your own. This is not difficult, and also allows you to experiment with different textures. Canvas for painting is sold in rolls by the larger art stores, and can also be bought from specialist suppliers. The stretchers themselves are also sold in art stores in standard lengths and are easy to assemble. Remember to prime your canvas before painting, with either an acrylic or an oil-based primer.

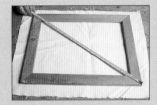

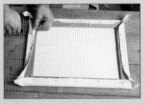

1 *Cut the canvas so that it is about 2-in (50-mm) larger than the stretcher frame. Assemble the stretcher, and check that it is square by measuring diagonally from corner to corner: if the measurements are the same, the frame is square.*

2 *Pull the canvas overlap up the sides and over onto the back of the stretcher frame. Secure at even 2 in (50 mm) intervals with staples.*

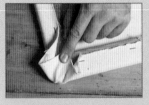

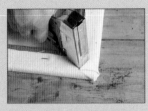

3 *One corner at a time, pull the corner of the canvas tightly over the stretcher toward the center. Fold one of the canvas wings in and over.*

4 *Repeat with the second wing, and then secure the fold to the stretcher frame using a single staple.*

5 *After priming, if the canvas remains limp when dry, make it taut by hammering a wooden wedge into the slot at each corner.*

Preparing board

Before priming a piece of masonite, either rub it over with glasspaper to remove the sheen and provide a key for the priming or wipe over the surface with denatured alcohol to degrease it. You can prime with either an oil-based primer or acrylic gesso, the latter having the advantage of drying very fast. Whichever you use, you will need at least two coats. If you want a slight texture, apply the brushstrokes unevenly, following different directions.

Along with the traditional tools already mentioned, fantasy artists will probably need some digital ones, including a computer, scanner, graphics tablet, software, and printer.

Digital tools

Your choice of computer is down to your operating system preference, which will be either Mac OS or Windows. Macintosh is the preferred system in the creative world, but most of the industry-standard software is available on both platforms and files can be easily transferred between them. If you don't have a computer already, talk with other fantasy artists to find out which is their preferred system and how each differs. Also, consider your budget. It is nice to have the latest digital equipment, but, if your budget is limited, buying a used computer can be a good idea. It may not have the power of today's machines, but in its day it was probably a cutting-edge piece of hardware and the work produced on it was no different to what you want to do now. Ensure you buy the highest-quality monitor, however, at the largest size you can afford. It will make working easier and will give you the most accurate color image, which is essential.

Finally, when buying a computer always purchase as much RAM as you can afford since graphics applications can often require a lot of memory.

Your computer
The Macintosh has long been an ideal computer for artists. Its fast processor, 20-in (51-cm) flat-screen monitor, and usability have made it a favorite for fantasy artists, illustrators, and animators.

A graphics tablet is vital for digital artwork, as it is a more natural way of working than using a mouse (which is a bit like drawing with a bar of soap). As a tablet is pressure-sensitive, you can emulate working with real pencils and brushes. There are models for a variety of uses and budgets.

Most scanners have high optical resolutions that are more than adequate for scanning line work to be colored digitally. Achieving high-quality color scans may be more difficult, however. If you are buying a scanner, ensure you purchase one that scans images at high resolution or have them scanned professionally.

Graphics tablet
The ability of a tablet and stylus to emulate a pencil or paint brush makes it ideal for the fantasy artist working with digital mediums.

Keeping your resolution
A scanner is a must for transferring your pencil or inked drawings onto computer. Scanners can copy your work at different optical resolutions, so be sure to set it accurately for whether you are scanning line work or a color image.

Other peripherals

Whatever computer equipment you buy, try to remember that they are just creative tools, like your pencils: no matter how powerful the computer or the range of your digital tools, they will not make you more imaginative or talented.

However, there are some pieces of equipment that are probably necessities for your studio. A digital camera is extremely useful for taking reference shots of people and places. A color printer is also handy, for checking your work. Ink jets continue to be the most affordable and give some of the best results. However, before purchasing research the available models carefully for print quality and the cost of printer cartridges. The initial cost of a printer may seem low, but a set of ink cartridges can cost the same price over and over again. You may find a second external hard drive to store your work is also a good investment.

For taking snap decisions
A pocket-sized digital camera is great for taking reference shots of scenery and people. The pictures can be loaded onto your computer and used as an element in your fantasy work or as a reference image for tracing.

Adobe Photoshop, a pixel-based software, is a favorite of many fantasy artists but there are many alternatives.

Digital software

Corel Procreate Painter is excellent if you want to imitate "natural mediums" such as watercolor or pastels. Though Photoshop can reproduce some natural mediums, it is no match for Painter. Vector programs, such as Adobe Illustrator or Macromedia Freehand, are great for working with flat color and precise lines. They produce small, resolution-independent files that can be reproduced at any size. Other programs such as Corel Draw and Deneba Canvas have a dedicated following and integrate pixel and vector tools into a single package. There are also some very good shareware and freeware programs if you are on a limited budget.

Another useful program is Curious Labs Poser. It has developed into a very sophisticated 3D-character-creation tool that will help you with body shapes, poses, and proportions. It also produces stunning images in its own right, and animations too.

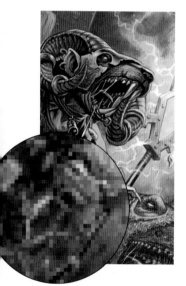

Pixel images
(Above) The more pixels put into the picture area, the sharper it will be, as in this detail from Ralph Horsley's Thanquol, *but while it can appear big and sharp on your screen it may be small when printed, or pixelate if printed larger than actual size.*

Vector images
(Right) The precise lines and flat colors of Adobe Illustrator can be easily edited.

BITMAP AND VECTOR IMAGES

Most software applications made for image editing and painting use bitmap images, but some programs—often titled "Draw" rather than "Paint"—support vector graphics. For pixel-based software, many people use Adobe Photoshop, but Corel Procreate Painter offers good imitations of natural mediums such as watercolor or pastel. Vector programs such as Adobe Illustrator or Macromedia Freehand are great for flat color and precise lines. Vector images are made of curves, lines, and shapes defined by mathematical equations. This means that they are resolution independent and can be enlarged without losing definition. Corel Draw offers pixel and vector tools in a single package.

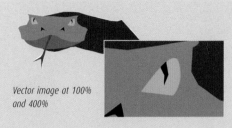

Vector image at 100% and 400%

If you zoom in on a scanned photograph or piece of computer artwork, you will see that the image is made up of a mosaic of colors. These are called pixels. Images made of pixels can create subtle gradations of tone and hue. However, since each image contains a set number of pixels, they are resolution dependent—they will lose detail and appear ragged (pixelated) if enlarged too much. To avoid this, produce your artwork at a resolution to suit the size of the final art. Three hundred dpi (dots per inch) at actual size is usually sufficient. In Photoshop you can set this in "Image," "Image size," "Document size." Before you start painting, enter the width and height at which you would like to print your final artwork, and then set the resolution to 300 pixels/inch.

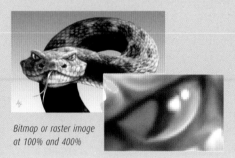

Bitmap or raster image at 100% and 400%

Picture resolution

Examine the deterioration in print quality of the three images below: 300 dpi (1), 150 dpi (2), and 72 dpi (3). The standard resolution for printed artwork is 300 dpi (1), whereas 72 dpi (3) is sufficient for online display because 72 dpi is the standard resolution of monitors.

Corel Draw

This silhouette of a dragon (right) was produced in Corel Draw. The small squares are fixed points that can be moved, and the lines in between them stretched to alter the curves. This makes Corel Draw ideal for producing simple line images.

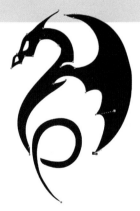

1

2

3

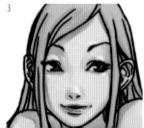

ILLUSTRATOR

Vector illustration software, such as Adobe Illustrator, uses mathematical equations and PostScript language to produce drawings. As a result, very small files are created, which contain images that can be enlarged to any size without loss of quality. Therefore vector software is ideal for turning a sketch made with natural mediums into a simpler digital image that can be viewed at any size in color or black and white. Images produced with vector programs are more hard edged than pixel-based ones, so an excellent choice for fantasy comics, especially if you use large areas of flat color.

Images made with vector applications are best output using

PostScript-equipped laser printers, although recent software releases do work well with inkjets. Illustrator and Freehand are the two market leaders, but if you want to explore vector-based natural mediums, have a look at the Expression range of software from Microsoft.

PHOTOSHOP

Adobe Photoshop is such a ubiquitous part of the digital toolkit of artists that it has become a verb. Images are no longer retouched but "Photoshopped." Although it was originally designed for the Mac as a digital darkroom for scanned images, it was quickly adapted as a standalone painting program and promoted into the dominating position it still holds today. Chances are you are already familiar with its functions, but you may still find some useful tips here (pages 66–71). If you need in-depth information, however, refer to a manual or online help for more information.

You can set up your Photoshop screen workspace for easy access to the tools you require. To the left is the toolbar where you can select and modify a wide range of tools, such as pencils, brushes, and erasers. To the right is the color palette and Layers window. Learn how to use layers as they will be valuable for editing.

PAINTER

Pixel-based software uses small amounts of data to represent a pixel (picture element) on-screen, making it ideal for photographs and paintings. Since every pixel is unique, such image files are very large.

Adobe Photoshop is the most popular pixel-based image-editing software, yet for those preferring a more natural look to their images, Corel Painter is in a league of its own. It has a wide range of brushes that can simulate different brush strokes in natural mediums from charcoal to oil and acrylic, and it enables you to achieve particular effects for your fantasy artwork by mixing different mediums together, such as pastel and watercolor, in a way not possible with the actual medium itself. It also incorporates non-traditional painting effects.

Other software, such as Corel Draw and ACD Systems Canvas, incorporate vector tools, enabling you to create vector and pixel-based images in one application.

POSER AND DAZ STUDIO

Poser and its rival DAZ Studio are two 3D software applications that the fantasy artist will want to experiment with. They can serve as virtual modeling agencies for figures and creatures, but they can also be used to produce striking stills and 3D animation.

Poser and Studio were originally designed to be used by artists, with Poser created as a digital version of the wooden mannequin, a character that is still present in the software. With anatomically correct models, as well as anime, fantasy, and cartoon characters, and a virtual menagerie of animals, you can build any type of scene as a drawing reference, or create 3D and animated worlds. Both applications come with figures and operate in similar ways, in that you take a model, modify it, add clothes, props, and environments, pose the elements, and render the final picture or animation. You can also add other applications to them, such as Bryce, which creates complex 3D landscapes and environments.

Dressing fantasy models
When creating your fantasy reference figures, you can also attach clothing to them.

If the face fits
Poser's built-in figures' faces can be adjusted in the Face room, and you can add your own photos of faces to map onto the figures.

Drawing and painting mediums

Any software designed for drawing and painting will provide a range of tools, from pens, pencils, pastels, and colored pencils to various brushes. Painter, for example, has a vast range of brushes and drawing implements, letting you work in more or less any medium you choose. In Photoshop the airbrush tools give varying effects by changing the opacity and pressure, and permits you to spray one color over another.

Programs vary, but most have a swatch tool you can pick colors from. The eyedropper tool enables you to select a particular color from your picture for use elsewhere in the composition. The dodge and burn tools in Photoshop enable you to lighten and darken previously painted areas of color and create shadows and highlights. When learning a new piece of software, familiarize yourself with the different tools and their effects by doodling with them. You may find it easiest to draw an initial fantasy sketch by hand on paper and then scan it to be digitally colored.

Painter brushes
Painter has lots of art brushes that replicate brush strokes and different mediums. The sample here shows different brushes including oil, airbrush, acrylic, watercolor, and charcoal.

Photoshop brushes
When you are using the brush tool in Photoshop, you can set the type of brush and size in the brush toolbox. To view this, click "Brushes" in "Windows," on Photoshop's top toolbar. The green marks represent different airbrush sizes. The blue marks show a marker pen-style brush. The pink marks show the more unusual brushes that produce a particular preset shape many times.

Bringing your imagination to life
Grey Thornberry uses diverse brushes to achieve the textures and details of the fierce combatants.

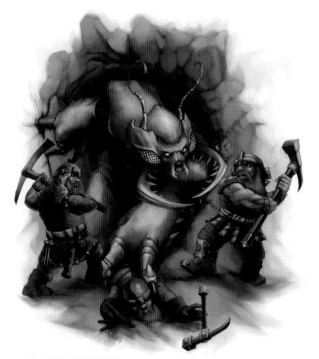

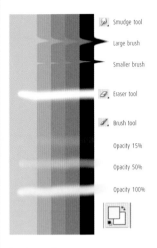

Smudge tool
Large brush
Smaller brush
Eraser tool
Brush tool
Opacity 15%
Opacity 50%
Opacity 100%

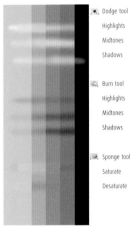

Dodge tool
Highlights
Midtones
Shadows
Burn tool
Highlights
Midtones
Shadows
Sponge tool
Saturate
Desaturate

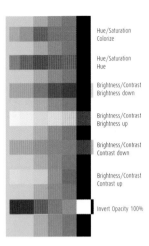

Hue/Saturation Colorize
Hue/Saturation Hue
Brightness/Contrast Brightness down
Brightness/Contrast Brightness up
Brightness/Contrast Contrast down
Brightness/Contrast Contrast up
Invert Opacity 100%

Brush smudge

There are various ways to paint in Photoshop. The swatch above shows the smudge tool, which can be used to blend or move areas of color, the eraser tool, and the brush tool. The brush tool can be altered in size and opacity. The lower you set the opacity, the more diffuse the color you add.

Dodge and burn

The dodge and burn tools are very useful for adding highlights and shadows to existing areas of color. The highlights, midtones, and shadows settings alter the levels at which the tones are affected. The sponge tool will increase or decrease the intensity of an existing color.

Hue brightness

It is possible to alter the shade, brightness, and saturation of colors. Select the area to be edited and then click on "Image," "Adjust". This will open a menu in which you can choose the function you require.

FILTERS

Filters can be applied to an image to create interesting effects. The image top right has been created by drawing with the brush tool. The images bottom right are the same images, with filters applied. To achieve the bottom left image, go to "Filter" on Photoshop's top toolbar, then "Distort," then "Twirl." You can adjust the level to which your image is distorted in the box that appears. The middle image is the result of "Filter," "Texture," then "Stained Glass." The bottom right image was created using "Filter," "Sketch," then "Chalk and Charcoal."

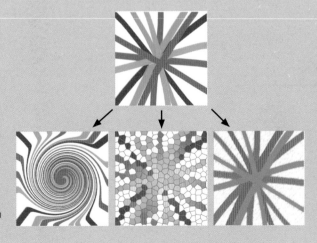

COLORING WITH PHOTOSHOP

1 This beast has been drawn by hand and then scanned into Photoshop. You can draw on the computer, but it can be difficult to get a good flow of line even using a graphics tablet, and many digital artists still prefer to sketch by hand. The dragon has been cut out from the white background. The background was selected using the magic wand tool. The image of the head has been placed on a separate layer (see page 69) so that future functions will affect the head only, and leave the background white.

2 By altering the levels in the Hue/Saturation function, the whole head has been shaded dark pink. The main areas that are to be different colors have then each been selected using Photoshop's lasso tool, and individually colored using the Hue/Saturation function.

3 Using the burn tool, shadows have been put onto the previously flat areas of color.

4 With the dodge tool, highlights have been added. The edges have been cleaned up using the eraser and smudge tools.

5 Using the brush tool with 20% opacity, different colors have been added over the top of the image to give more variety of color. The head has been "selected" so as not to affect the surrounding area. More smudging and further use of the dodge and burn tools on a small brush setting give the details.

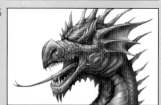

6 A background has then been added to complete the picture. The separate white background layer is behind the dragon's head and therefore can be altered without affecting the dragon itself (see page 69). Various shades of orange have been sprayed on with a large setting brush to create the volcanic cloud effect. The colors have been picked from the "Swatches" box, which you can access by going to "Window" and ticking the "Swatches" option. Whichever swatch of color you click on will be selected for use with the brush.

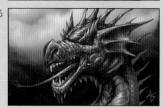

Coloring digitally

The wide range of drawing, painting, and photoediting programs available allow you to color with different effects, styles, and methods of working. You simply need to choose the software and methods you prefer. Some artists like to build up color with layers, which can be visualized as pieces of transparent film stacked on top of one another. When you make a drawing or scan in a photograph, it appears as a background layer called the canvas. Since the layers are independent of each other, when you create a new layer on top of the canvas you can work on it and apply various effects, such as changing the color and opacity, without altering the underlying image. Similarly, you can work on the canvas without affecting any images on other layers. Layers are especially useful for collage-type compositions, in which images, shapes, or textures are superimposed over others.

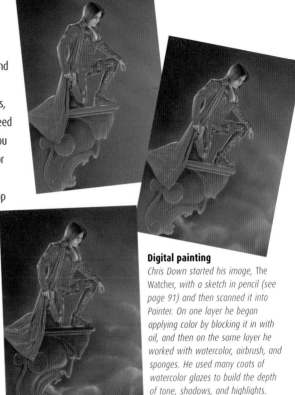

Digital painting
Chris Down started his image, The Watcher, with a sketch in pencil (see page 91) and then scanned it into Painter. On one layer he began applying color by blocking it in with oil, and then on the same layer he worked with watercolor, airbrush, and sponges. He used many coats of watercolor glazes to build the depth of tone, shadows, and highlights.

Other artists prefer the painterly qualities of software such as Painter and may choose to work almost solely on one layer, or the canvas, and apply the color in a similar way to an artist working with natural mediums by using a graphics tablet. In this way the color, shadows, and highlights can be applied in many coats of a medium, for example oil, watercolor, and glazes, applied with different brushes, sponges, and other equipment.

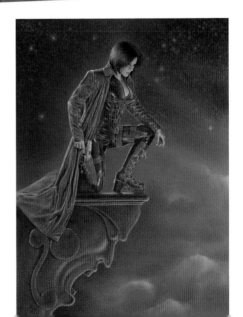

LAYERS IN PAINTER

The Layers palette will help you organize your work, plus if you make a mistake it is easier to rectify because you are dealing with only one layer at a time. If you are working with lots of layers, make sure you name them. The selection tools contain the normal marquee tool (1), both round and circular, a lasso tool (2), a magic wand (3), a color picker (4) for selecting items of the same color, and a tool for resizing the selection (5).

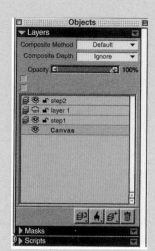

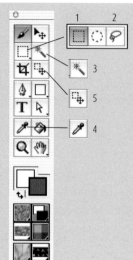

PHOTOSHOP

One of the most useful functions in Photoshop is the ability to put different elements on different layers. The Layers window (below) allows you to turn the visibility of each layer on or off and to adjust transparency using the opacity percentage slider. A number of tools are available to select various parts of the image, all of which are found in the toolbar (1). The marquee tool (2) is useful for simple geometric shapes, the lasso tool (3) for drawing around chosen areas, the magic wand (4) for selecting areas where the color or tone is distinct, the picker tool (5) to sample a color that is linked to a selection dialog box, which allows you to adjust the range of the selection through the fuzziness slider, and the quick mask tool (6), which allows you to paint a selected area.

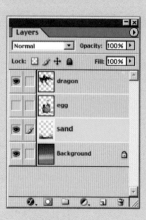

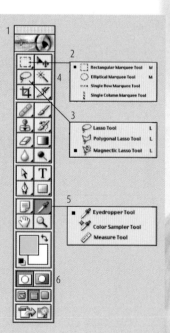

USING LAYERS IN PHOTOSHOP

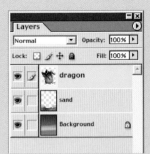

Here the sky is at the back (bottom of the list). The sand is on top of this, followed by the egg and dragon.

The "Layers" window (left) is accessed through "Windows" on Photoshop's top toolbar, then clicking the "Layers" option. You will see a small thumbnail of the object on each layer displayed on the appropriate bar. The layer you are working on will be highlighted in blue. To change layers, just click on the one you want. You can alter the layer order by dragging one layer above or below the others in the list. Where an upper layer overlaps a lower layer it hides any of the layer that is behind it, so it is important to put your layers in the right order.

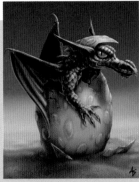

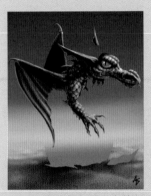

This dragon has been created on four different layers—the dragon, the egg, the desert sand, and the background.

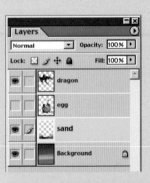

To hide a layer, click on the eye symbol to the left of the window. Here you can see the eye on the egg layer is missing. To bring the layer back into view, click on the eye box again and it will reappear.

Here, two layers are linked (left). You can see the link symbol in the dragon layer, which is now linked to the egg. If the egg is moved, the dragon will also move. To add or remove links, click on the link box.

Linked layers can be combined into one layer (right). Make sure the required layers are linked, then click on the small arrow in a circle on the top right-hand corner of the Layers box and click on "Merge Linked."

Here, the egg layer has been hidden, revealing the background behind it.

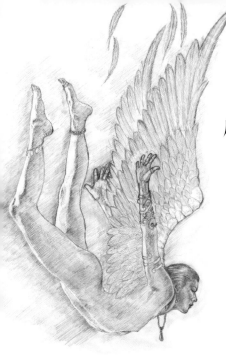

You can incorporate digital processes into your fantasy art at any stage.

The digital process

Many fantasy artists use a combination of traditional and digital processes to create their art. This enables them to benefit from starting with the spontaneity of applying pencil or charcoal to paper. Then, once they have scanned the image, they can exploit the technology of painting software to create images that would not be possible in traditional mediums alone.

1 *Chris sketched the figure on drafting paper, added his own details, and planned the composition.*

2 *With the sketch scanned into the computer, Chris blocks in color to set the overall color scheme.*

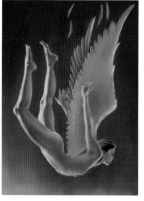

3 *On the same layer, he begins to refine the detail of the figure, face, and hair with highlights and shadows.*

4 *The jewelry is roughed in on a separate layer, so the skin can be painted without affecting the jewelry.*

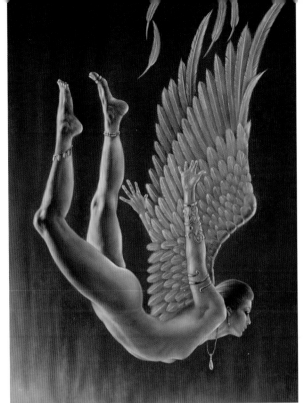

From photograph to painting

Chris Down was inspired to create Fallen Angel after seeing the photograph above by Marcus Ranum. In one photograph he was able to draw on the anatomical information he needed and have a jumping-off point from which to develop his own fantasy idea (right).

5 *The position of the hands is changed to ensure they are anatomically accurate.*

6 *Detailing of the jewelry, skin, and feathers is developed. The background is deepened with a color glaze.*

7 *The image is flattened to merge the jewelry with the skin, and more watercolor glaze is applied.*

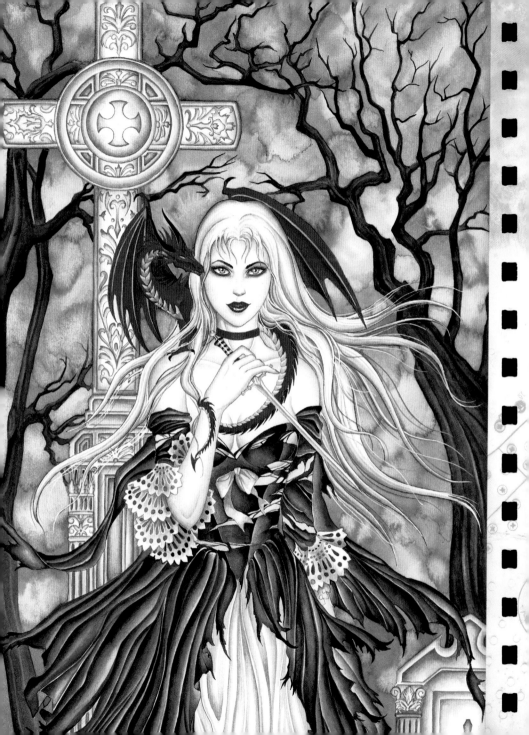

2 Planning

The vital first step is to have a working space that is comfortable, maintainable, practical, and—above all—conducive to producing fantasy designs.

Working habits

You do not need to micromanage your workspace from the start. In fact, it is much better to let it evolve naturally as you begin working. However, there are some key considerations you must take into account. For example, frequent interruptions can break a run of inspiration, or a highly productive spell, so try to ensure that you can be free from distractions. You need room to lay out visual sources and other reference materials, including any work with a similar theme that you may be drawing on for inspiration. This not only takes up more space than you might expect but can grow exponentially if you are working on multiple projects. Also, set up a simple system that can help you manage a balance between structure and spontaneity, so that you can always find your equipment without having to hunt for it, or draw on particular research materials.

ACCESSIBILITY

Be practical about your work area. Try to set aside a space where you can control the working conditions. The larger and cleaner the workspace you start the day with the better, and check the position of the light source as it is important to minimize glare or shadow on your work surface.

Think it over
A good idea is to pause and daydream about your subject. Sculpt images in your head and see how much they arouse your interest before expending effort on them.

Have a plan
Just sitting down and sketching ideas can prevent you from exploring new concepts. You can put in a lot of effort only to discover the idea was not very interesting to start with.

Pin your ideas down
A bulletin board next to your work area provides an excellent visual material.

The old adage of "10 percent inspiration, 90 percent perspiration" is something to be taken seriously when embarking on your fantasy work.

Looking
for inspiration

Moments of true inspiration are rare, and usually happen when you least expect them. For this reason, always carry a notebook so you can jot down your ideas before they disappear. Inspiration usually strikes when the mind is free from extraneous thoughts, when you are relaxed, or involved in other activities. The mind is also receptive first thing in the morning, before it becomes too active. Unfortunately these situations are hard to control, but when the moment comes you have to grab it with pen and paper.

Not all inspiration is spontaneous; you can trigger ideas by reading novels, comics, newspapers, and web sites and collecting a body of inspirational visual material digitally and in print. If you are willing to look, you will find a wealth of sources that can act as catalysts for thoughts that have been floating around in your head. You can take an existing concept—robots, for example—and add your own personality and imagination, allowing your ideas to develop in all sorts of fantastical directions.

Inspiration and research
Newspapers, magazines, novels, classic literature, movies, and audio books can all be triggers for stories and give information about unexpected people and places.

Keeping notes

A tear-off notebook or drawing pad is always a useful thing to keep in your pocket or bag, for jotting down ideas or making quick notes and sketches.

Sources of inspiration

Working with existing characters is a good way to start. Reading the legends and mythology of other cultures will also serve as jumping-off points for your ideas.

Inspiration comes from all sorts of influences, so it is a good idea to read a lot and to read beyond your favorite genres. For example, try reading biographies—a great way of adding a new reality to your characters. Also expand your type of reading; if you only read novels then try comics and newspapers. A lot of great ideas can be culled from the pages of the daily papers. Truth is often stranger than fiction. No matter how you get your initial ideas, ensure you keep notes and use both written ideas and sketches to build a full picture.

Try to keep your pictures accurate by doing proper research. If you are setting your picture in a city, make sure you represent it correctly. Your research should also apply to cultural and historical references, if these are part of your image. By paying attention to these details your fantasy picture will have more impact when juxtaposed against reality, making your job of getting the viewer to suspend disbelief much easier. However you arrive at your ideas and choose to portray them, let reality and its rules infuse your fantasy worlds to give them maximum impact.

ALTERNATIVE NEWS WEB SITES

There are hundreds of conspiracy and alternative news web sites, where fact and imagination make an incredible source of stories and characters. "What if..." is a great way to get the creative juices flowing.

DIGITAL RECORDING

Photographing interesting people and places you visit will serve as a useful resource that will last a lot longer than your own memory.

Classical art schools often tell pupils that the best way to learn is to study pre-existing art. This is true for fantasy artists too.

Drawing
and research

You can study art that already exists by sketching it and building your understanding of how artists develop their compositions. Also, try drawing from life—another staple of art education. Although drawing from life and studying existing works may seem disconnected from the creatures of a fantasy world, they are necessities. Whatever the subject of your work, you will need to understand composition, three-dimensional form, and how such forms interact with their environment to gain a mastery of rendering all sorts of beings and structures. By studying them through drawing you will have the chance to practice, and try out and plan your own ideas. Ensure you draw to varying levels of detail too. Sometimes a loose sketch to copy a composition is best; at other times you will need to sketch carefully to benefit most from your research.

Developing concepts
A drawing of a figure can often provide the basis of a fantasy creature. In Heather Hudson's sketch, The Eye, *the creature crouches in a pose that is recognizable as one a human might make. Yet she has developed the image into a powerful fantastical beast, through the exaggerated muscles, lengthened arms, and the claws and horned head.*

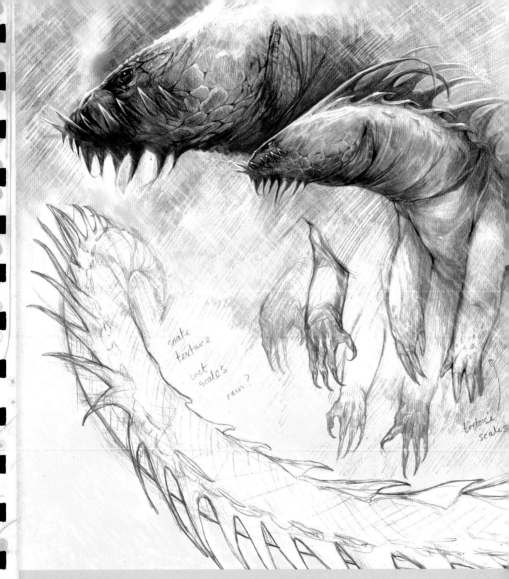

snake
texture

wet
scales

rain?

tortoise
scales

Expanding your ideas

Scribbling written details and notes as Mike Nash has done in his image Dragons can be a quick way to lay down ideas or expand on particular visual elements.

The sketching stage is also the ideal time to try out different ways of representing your subject or aspects of them, such as the multiple limbs and claws above.

People love a good story and there are certain tales that have been popular for centuries, which may be ideal for your fantasy worlds.

Mythology and art

Storytellers have held a special place in society. In ancient times they may have been mystics, oracles, and shaman; today authors, screenwriters, and musicians fill the role, while filmmakers, artists, comic artists, and animators can be seen as visual storytellers.

Telling stories with pictures has been part of our heritage since the first drawings on cave walls. From the Australian Aborigines and ancient Egyptians to the Mesopotamians, Chinese, and Aryans of the Indus Valley, and up to the time of the Greeks and Romans, pictures were used to record and recount tales of valor and to teach the lessons of the gods. The mysteries of the world were revealed and explained through metaphor and symbolism, with the artists supplying their visions as clues and prompts. It was from these mystical roots that mythology—and the archetypal characters that populated the stories—developed. Later artists continued the storytelling tradition in drawings, prints, and paintings, particularly in those carrying religious and moral teachings.

Gods and monsters
To tell good stories characters are made to appear differently than they really are. The Egyptians (right) made their pharaohs into gods, while the story of Adam and Eve (above) simply defies logic in the name of a good story with a strong moral message.

VISIONARY ICONS

During Medieval and Renaissance times, most of the art created in Western Europe served the Christian Church by representing figures and stories from the Bible, and other Christian moral tales. Following the Reformation, as other Christian faiths developed alongside Roman Catholicism, some artists such as William Blake in Great Britain began creating images filled with visionary scenes that reflected their own mythologies. From the later 19th century there was a resurgence in allegorical painting, with schools such as the Pre-Raphaelite Brotherhood, also in Britain, and the Symbolists in France and Belgium producing figurative paintings based on traditional myths. Their fascination with myths and legends, coupled with improved education and printing methods, saw the rise of illustrated mythologies by great draughtsmen such as Gustave Doré, Arthur Rackham, and Walter Crane.

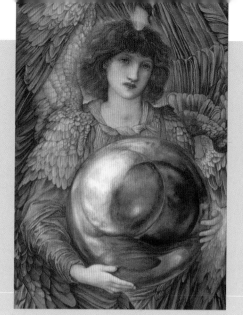

Brave new world

In the 20th century, with the rise of technology and ease of travel, the world seemed to grow and shrink simultaneously, and different cultures were introduced to new sets of legends, mythologies, and religions that were diverse yet somehow similar. Though great minds, such as Carl Jung, integrated these discoveries, the harsh realities of the global warfare of World War II changed perceptions. Ordinary people were carrying out heroic deeds on a daily basis, and people wanted new mythical heroes in easily digestible and affordable formats: movies and comics provided the solution. The much-needed escapism was supplied by Hollywood superstars and pulp-paper superheroes, but while the actors became legendary, they were far too human when compared to the comic-book heroes who have stayed on our screens and in our comics for decades.

Fantastical allegorical

Art and illustration at the end of the 19th century was heavily influenced by myths and legends. The Pre-Raphaelite painter Edward Burne-Jones (top) offers a more romantic view than the "darker" visions of artists such as Doré and Crane (left).

The popularity of fantasy art stems from its ability to create a sense of wonder. It intrigues audiences with visual ideas and concepts that seem new and out of the ordinary—different in some way from the everyday.

Conceptualization

By being concerned with creating new worlds that can be described as alternative realities, the fantasy artist displays to the audience strange landscapes, weird creatures, fantastic vessels and buildings, supernatural phenomena . . . and portrays them in ways that set fire to the imagination.

Every fantasy artist and fantasy writer is asked from time to time where they get their ideas from. It can be difficult to give a practical response, because the most truthful answer may be "From inside my head." This does not offer much help to the novice, who may then counter with a further question: "How do you arrange matters inside your head so that such ideas become available to you?" While this question is less easy to answer, the process is, in fact, not all that complicated. Whatever your fantasy interest, there are well-trodden routes by which you can unleash your imagination to create new concepts and develop them through the various working stages to a finished picture.

Creating character
In Carrion *Mike Nash sketches out his three menacing figures in differing profiles and varying levels of detail. The loose handling of line renders the overall qualities of the background figures, while in the foreground the details of the clothing are becoming clear.*

DRAW CONSTANTLY...

To become adept at creating fantasy worlds, you must treat it in the same way as the acquisition of skills in any area—you must practice. To develop your practical skills in delineating form and structure, light and shade, perspective, picture composition, and all the rest you will need to use your sketchbook, drawing from observation. You will also need to sharpen your inventiveness by drawing and doodling the kinds of fantasy subjects that interest you from imagination—but you need to root your fantastication in experience of the real world. Anything you see in the everyday world around you is worth a sketch—street scenes, vehicles, people on trains or in cafes, and so on—so carry your sketchbook everywhere, and do not be shy of using it.

The sketchbooks of imaginative artists are full of drawings from life—along with memory sketches, bits of invention, and flights of fancy, plus odd notes and jottings made when ideas have occurred to them.

Working from imagination

As a fantasy artist you can set your imagination free to sketch a pot-pourri of ideas. Here, fantasy characters and space hardware are interspersed with story ideas and oddball flights of fancy. The lines and shapes are continually developed using a pencil and eraser as the drawing progresses.

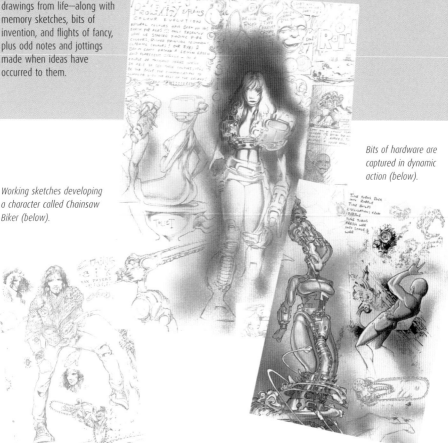

Bits of hardware are captured in dynamic action (below).

Working sketches developing a character called Chainsaw Biker (below).

Mixing drawings from observation and imagination

The illustrations on this page are notebook and sketchbook pages for various projects. The artist works up his ideas along several different lines at once, mixing drawing from observation and imagination with extensive notes.

Early study in pen and smudge (below). Notes and working drawings "thinking about the need to transform fantasy into fact" (bottom).

"Confusion of direction—which language to use to react to looking?" A working drawing/quick study in the artist's notebook (above).

Notebook studies (above), and (inset) image for a poster.

STAGES OF A COVER PAINTING

The artist was commissioned for the cover of a publisher's catalog. The brief was simply "books." The first idea was to show a wizard with a book of spells. In one of the character sketches for his face, the wizard had a fantastically long beard, and this led to the introduction of the long-legged stool—otherwise, his beard would trail on the ground—and from this developed the character of the scholar with a candle. Sketches of the background followed, then the large detailed drawing as the final stage before starting on the finished artwork. All these drawings were done in ballpoint pen. The first color version was done in brown ink and colored with watercolor. For the second version, a wash of warm ocher was laid over the whole picture area. The scholar and the floor area were masked out with masking film, and deep brown was sprayed on with a spray gun, followed by a further sprayed layer of Prussian blue over the upper half. The scholar himself was then painted in detail in gouache. Oil pastels were used for the candlelit stack of books, and other details were painted in gouache.

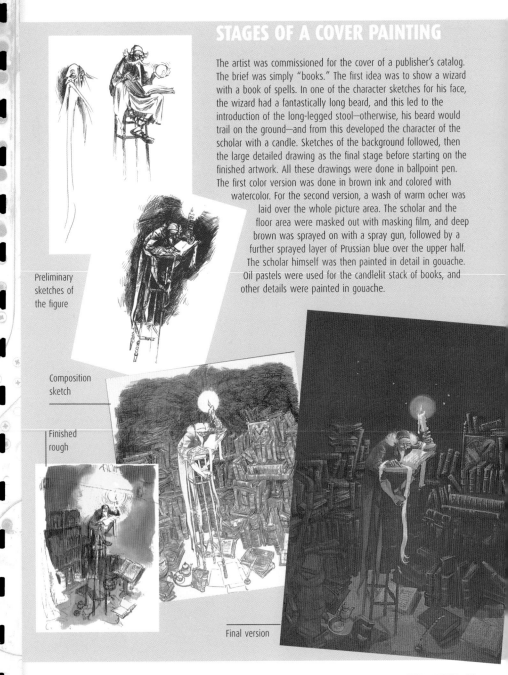

Preliminary sketches of the figure

Composition sketch

Finished rough

Final version

Developing ideas in paint

Jon Hodgson planned the composition of his picture *Initiative* with some rough pencil sketches that enabled him to position the dragon, castle, and precipitous landscape. However, he continued to add smaller elements to increase the drama of the story as he worked through the stages of the painting.

1 *Make a few sketches to establish the character of the dragon.*

2 *Once the pencil drawing is scanned into the computer, basic colors and shapes are applied on top of the sketch in Painter.*

3 *The main color focal point— the splash of red on the dragon—is set down as all other colors will revolve around it. Jon also starts to detail the dragon.*

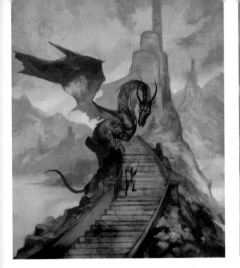

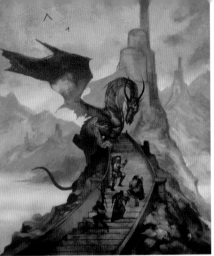

4 *Detailing of the dragon continues and the first figure is added mounting the steps.*

5 *More detail is added across the canvas and the characters are developed and fleshed out. Some birds are added in the sky.*

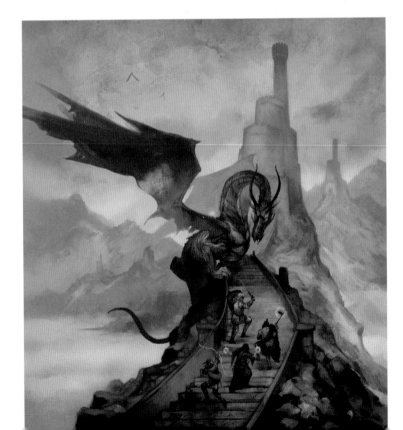

6 *The final polish takes place to bring out colors and shadows.*

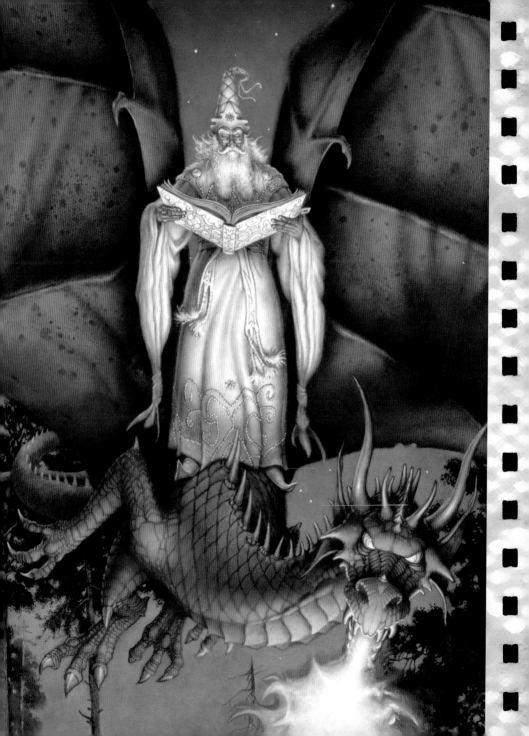

3

Fantasy art concepts

Booked Flight
Don Maitz

Almost all fantasy illustrations, no matter their settings, contain figures with human traits, such as fairies, giants, dwarves, superheroes . . .

Human-oid

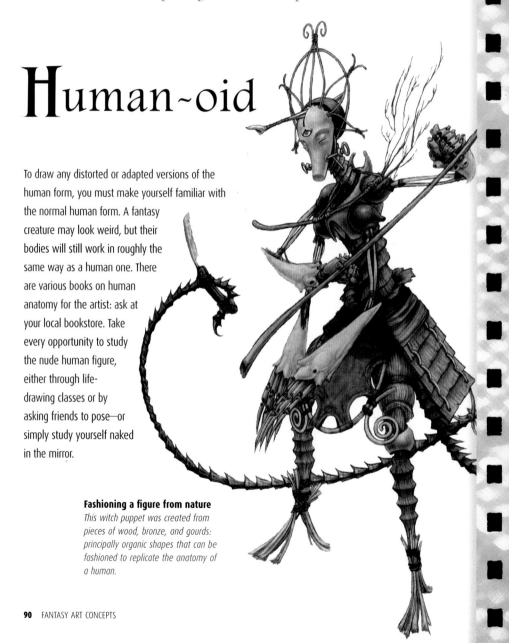

To draw any distorted or adapted versions of the human form, you must make yourself familiar with the normal human form. A fantasy creature may look weird, but their bodies will still work in roughly the same way as a human one. There are various books on human anatomy for the artist: ask at your local bookstore. Take every opportunity to study the nude human figure, either through life-drawing classes or by asking friends to pose—or simply study yourself naked in the mirror.

Fashioning a figure from nature
This witch puppet was created from pieces of wood, bronze, and gourds: principally organic shapes that can be fashioned to replicate the anatomy of a human.

ANATOMY OF A FANTASY FIGURE

In order to make the proportions of a fantasy humanoid look plausible, use the head as a unit of measure. The body of a normal human is six to eight heads in height, and you can increase or decrease this ratio to create particular impressions about the type of human/humanoid you are illustrating. However, remember to study people in the real world before going on to depict figures in the unreal.

A height of eight heads is at the top of the range for normally proportioned human figures. To make gnomes look short and stocky, use a head-height of about four or five (above). Conversely, a superhero's head-height could be nine, ten, or even more (right).

Drawing from life

When drawing a model, pay special attention to the body's proportions. Try to see how the important joints work. Study the bone and muscle organization, and look at the distribution of mass around the body—the way the various masses respond to gravity in different poses. Think always about how the parts of the body work, and how all those bits function together so that the body as a whole works. Get it right: don't be tempted to produce an idealized portrait.

Carry a sketchbook everywhere. Watch how people move and behave when they're performing different actions or when their minds are engaged in various activities. Don't be frightened of concentrating on a particular area to the exclusion of all else until you know how it functions.

Studying poses
If you do not have the time or space to draw from life, careful photographs like Chris Down's for The Watcher *(see page 67) may suffice.*

Experiment

Once you are completely familiar with how normal human bodies work, you can start to experiment with abnormal ones. Here you are likely to be performing a con trick on the viewer. The superhero with muscles bulging in more directions than you knew you had muscles might well be unable, in real life, to walk around without pulling himself to pieces, but your fundamental knowledge of the human body will enable the illustration to look convincing.

Creating part-human creatures
This humanoid has humanish limbs with a reptilian torso and head. The overall reptilian nature is enhanced by the coloring.

CONVINCING POSTURE

Your humanoid will look convincing only if you have correctly planned the posture and distribution of the bodily masses. Sketch a simplified version of the skeleton (not just a stick figure) first to make sure you have these points right. This example shows the sort of thing you should be doing.

HEAVY OR LIGHT

It is evident in this color drawing that two of the characters are bulky while the dancing quartet are ethereal. Line, color, coarseness of feature, bodily shape, and even facial expression combine to create the required impression.

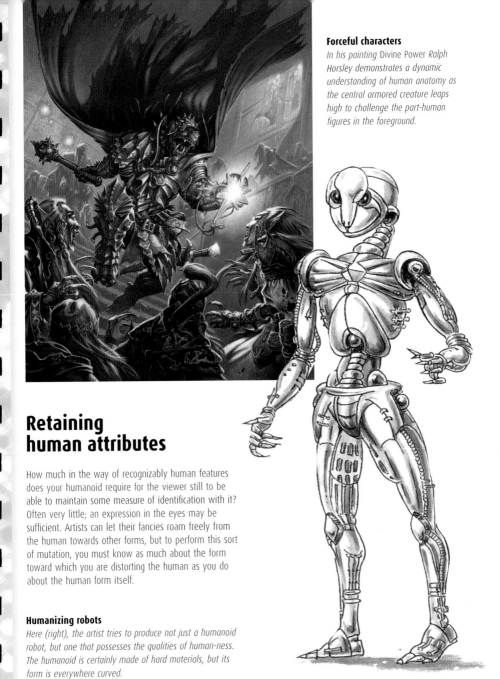

Forceful characters

In his painting Divine Power *Ralph Horsley demonstrates a dynamic understanding of human anatomy as the central armored creature leaps high to challenge the part-human figures in the foreground.*

Retaining human attributes

How much in the way of recognizably human features does your humanoid require for the viewer still to be able to maintain some measure of identification with it? Often very little; an expression in the eyes may be sufficient. Artists can let their fancies roam freely from the human towards other forms, but to perform this sort of mutation, you must know as much about the form toward which you are distorting the human as you do about the human form itself.

Humanizing robots

Here (right), the artist tries to produce not just a humanoid robot, but one that possesses the qualities of human-ness. The humanoid is certainly made of hard materials, but its form is everywhere curved.

Movement brings a fantasy art image to life, adds interest, and helps to flesh out character.

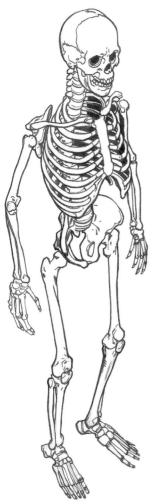

Anatomy

When constructing a fantasy character, making a complete drawing all at once is difficult. It is easier and much more effective to construct a figure in stages. The first stage is the skeleton, which is then used to establish posture, proportions, and action. The skeleton acts as the framework on which to hang the muscles and flesh. It is therefore important to draw the skeleton in a position that looks natural for the figure. A simplified figure is the perfect way to start constructing a character. Practice drawing skeleton models in different actions, so that you can create positions that look natural.

Action poses
In action, the hulk's extreme physique is on display, every muscle exaggerated and given definition.

Springing into action
This pose shows that even so vast a bulk can be given grace, speed, and agility if handled right.

Anatomy
A basic knowledge of the skeleton helps fantasy artists draw convincing human or humanoid figures.

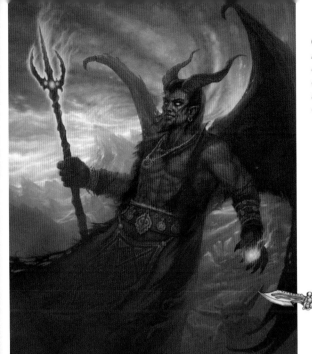

Convincing anatomy
Howard Lyon's Mephistopheles
*demonstrates the artist's knowledge
and understanding of anatomy,
musculature, and movement to highly
dramatic and dynamic effect.*

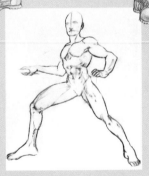

FIGURES IN ACTION

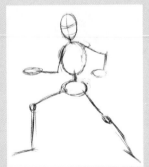

Simplified skeleton
Start with a skull, ribcage, pelvis,
hands, and knees, represented by
simple oval shapes, Finish off the
sketch with lines representing the
limbs and feet.

Adding muscles
Continue to think in primitive shapes
as you start to map out the muscles.

Finishing touches
Pencil in an outline for the figure,
adding more muscle detail and some
facial features, as well as fingers
and toes.

In everyday life we convey almost as much through our bodily posture as we do through the words we speak and the tone in which we speak them.

Body language

Victory

Moving forward, the arched back and pushed-out chest make this pose dynamic, while the tensed, raised arm and upward tilt of the head gives a noble and imperious bearing.

Much of the meaning of speech resides in the body language of the person who is speaking. For example, the statement "Please wait your turn" can be a command, or a request, or a suggestion, or a supplication. If the person has their chest puffed out, they are telling you to do something; if their shoulders are slumped and their face upturned toward yours, they are begging you to do it.

The ways in which people move give a key to their characters and even their occupations. The firmness of the line you use is one way of conveying this. Imagine there's a panic on the deck of a starship. Someone reaches to flip a vital switch. The strong, firm lines of the arm and hand can show that this is the competent pilot; conversely, the same arm and hand can be fuzzily delineated (as can the switch itself) to show that this is someone who doesn't really know what they're doing. Or the fingers could be long and delicate, their movements apparently superbly precise—like those of a musician on the strings of a musical instrument—to convey that the individual performing the action is not a human being at all.

I shall have revenge

After being forced to kneel in a submissive pose, the figure's posture changes slightly as her arms bend in at the elbows as she starts to rise.

TRICKS OF THE TRADE

Do not be too frightened of making your characters perform exaggerated, actorish gestures. Remember you are giving the viewer visual cues, not accurate depictions of reality. If you came across someone in real life who used the body language of a stage Romeo, you would laugh, but that same body language, on stage, conveys powerful emotions. Remember: in a way, fantasy art is a performance art.

In this pose (right), with feet firmly fixed on the ground, the character makes ready to grapple with an opponent. His whole body is taut, with the main areas of tension visible in the arm, shoulder, and calf muscles.

Wrestling bout
With feet firmly set on the ground, the warrior makes ready for combat. His whole body is tense and the main areas of muscle visible.

Choosing the right pose
Rob Alexander creates an impressive and forceful female fantasy figure in The Exalted Angel. *She appears proud, powerful, and dramatic.*

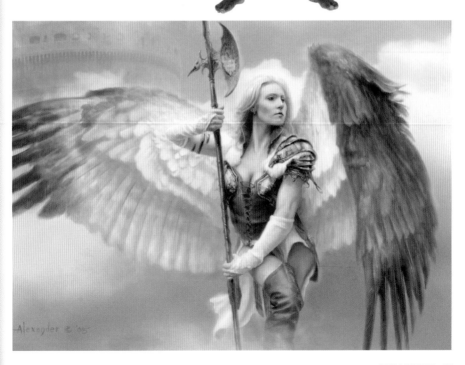

Today we are so bombarded with images of different human types that it is hard to avoid making every fantasy character a cliché.

Characterization

To give visual clues as to the type of character portrayed the fantasy artist needs to use clichés. If you don't make the barbarian mighty-thewed or the wizard scrawny and bearded, you may create a character the viewer can't interpret so to some extent, your characters have to conform to a perceived norm—however silly that norm might really be. It is up to you, however, to superimpose touches of individuality on the clichés.

Facial and cranial shapes can be categorized as brachycephalic, dolichocephalic, and mesocephalic. In the brachycephalic look, all the facial features tend toward breadth rather than length. The profile is flattish—the nose does not jut much. Associated with the narrow-headedness of the dolichocephalic look is protrusion of the features—the nose is likely to be jutting and beaky. We intuit that the person is ascetic and esthetic—they rely more on brain than on brawn, and can be vulnerable. At the same time they can be cruel.

Facial and cranial classifications
Anthropologists used to divide people into three categories: brachycephalic (broad-headed), dolichocephalic (narrow-headed), and mesocephalic (in between). These categories remain important to the artist because we all instinctively ascribe character attributes to different face shapes.

Mesocephalic

Brachycephalic

Dolichocephalic

The mesocephalic look is what the ordinary person in the street has—it is neither broad nor narrow. As a fantasy artist, you can use this facial shape to portray exactly such a character: Mr. Everyman. This is the type of person whom you instinctively want to use as the mundane persona of a flamboyant superhero. In making this connection, you are pandering to the wish-fulfillment fantasies of your viewers, most of whom are likely to be average, mesocephalic people. Don't be afraid of making that connection!

Creating the hero
Ruan Jia draws on the mesocephalic look to develop the dominant features of his hero's face, while introducing elements of individuality.

A fantasy artist's touchstone
The facial categories are useful tools for fantasy artists, giving them a base from which they can depict strong characters such as the wicked fairy portrayed in Thomas Baxa's Infused Allure.

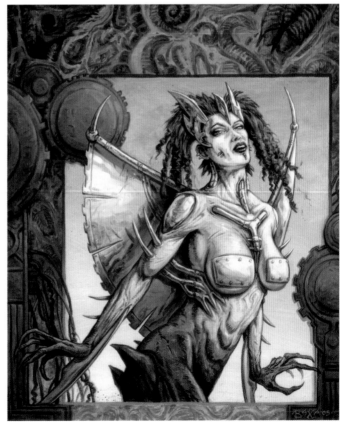

SOMATOTYPING

This body-shape classifying system recognizes three types: ectomorph (fragile-seeming, bony, minimal flesh and muscle), mesomorph (heavily boned, square, fairly well-muscled), and endomorph (more softly rounded shape, large abdomen, small hands and feet, generally fleshy).

ectomorph

mesomorph

endomorph

Facial flesh

Whatever the basic facial shape, you can alter a character's perceived personality by adding facial fat. The five primary locations in which facial fat appears are from the side of the nose down to the corner of the mouth (1), around the jowls (2), on the chin (3), beneath the chin (4), and under the eyes (5). In the final drawing (6), extra fat has been added in all five locations.

1 2 3

4 5 6

Exaggerating facial characteristics
The different locations of facial fat shown above can be exploited to give your characters exaggerated personalities, and so can the proportions of the face. In this group of thumbnail sketches both techniques have been deployed to produce a wide range of perceived personalities.

Hair

The pattern of hair on a character's face and skull can be used to convey personality.

Curly hair can make someone look frivolous; straight hair tied tightly back makes them seem self-controlled, perhaps icy, or uncommunicative. Straight hair swept back off the forehead can be used to make a man seem arrogant or bombastic, but add glasses and he can appear severe or intellectual.

Clothing

The way in which someone is dressed gives a strong clue as to what job they normally do and their character. Clothes not only indicate role and function but also express personality and potential.

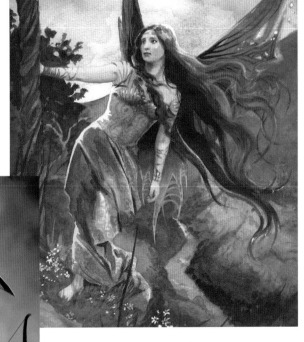

Bringing the elements together
The long floating dress and loose flowing hair of Kajsa Flinkfeldt's figure (above) perfectly evoke the ephemeral quality of wind, the painting's title, while in Lady Assassin *(left), Eric Lofgren's character is aptly dressed for her murderous role.*

The word "anthropomorphism" means the perceptual endowment of something nonhuman—whether living or dead—with human attributes.

Anthropomorphism

In written fantasy and science fiction, anthropomorphism is something often done with creatures that are nonhuman. Sometimes fantasy and science-fiction writers can fall into crude conceptual vocabulary, so for example, if the figures from Tau Ceti II are described as squat and smelly, that's a sure clue they're bad guys because in fiction these attributes tend to be associated with villainy, while if they are tall and broad shouldered they are most likely heroes.

To the fantasy artist, anthropomorphism means the grafting onto things that are dead (or at least immobile) characteristics of things that are living and mobile. A house, even when depicted as a collection of bricks and mortar, may also be portrayed as sentient—as having a will of its own. By extension, non-sentient living things may be regarded as fully conscious—like the Ents in Tolkien's *The Lord of the Rings* (1954–55), who are walking trees and have personalities.

Humanizing trees
Alan F. Beck cleverly plays with the viewer's perceptions in Wizard Tree *(left) as it gradually becomes clear the elements of the tree form a stoical wizard.*

The idea of the quasi-human tree has a long history. Everyone has looked at the crenellations on a tree's bark and seen faces there. In the late 19th and early-20th century, fairytale illustrators like Arthur Rackham rejoiced in showing trees with human faces, while the Druids seem to have regarded trees as having souls and faces (an archetypal belief is that the possession of a face implies possession of a soul). Trees are not the only ones given the illusion of (human) life by the projection onto them of faces: sometimes other natural features such as a rocky crag are given the qualities of humanity through delineations of a human face.

Humanizing the non-human

This is a way of imbuing inanimate objects with a certain eerie presence which otherwise they would not have. In this line and wash image of a "human tree," roots and vines play the part of bones and sinews.

Building character in the non-human

In humanizing objects and natural forms the fantasy artist has a great opportunity to develop character and personality. Often objects are imbued with qualities that evoke an eerie presence, but here Marc Potts creates a gentle image of an ancient tree watching over the safe passage of the small twinkling spirits.

Getting beyond the obvious

A more interesting option than merely grafting living features onto inanimate objects is to give them a feeling of presence.

One way you can do this is to give them not features but overall shapes that call to the viewer's mind the idea of something living—that hint at sentience rather than showing anything specific that might be thought of as sentient. If you show a person running away from a huge chunk of rock that looks as if it is top-heavy and about to topple forward, the viewer will interpret the rock-formation not only as threatening, but as crouching, about to spring. There may be no direct visual cue suggesting to the viewer that the cliff is sentient, yet that is nevertheless the idea that—through subtle visual allusion—is conveyed.

Establishing presence
The face in Mike Nash's Visage *seems to emerge out of cobwebs and hardware to fill the picture surface with a deep menacing quality.*

GRAPHIC GEOMORPHOLOGY

The artist can play with the viewer's emotions by using landscape shapes that are reminiscent of the human form in some way.

In this painting the artist merges the dark forms of the rock and the tree to make a threatening—and humanized—shape. The main source of the humanization, however, is the figure in the foreground, without whom the landscape would be devoid of threat.

Friendly (or distinctly unfriendly) hardware

Do not forget that you can give machinery the appearance of having personality. The grin on a robot's face may make the machine either friendly or terrifying. A similar line put subliminally into the depiction of a spaceship can mean that it stops being a machine and becomes a "person" with character.

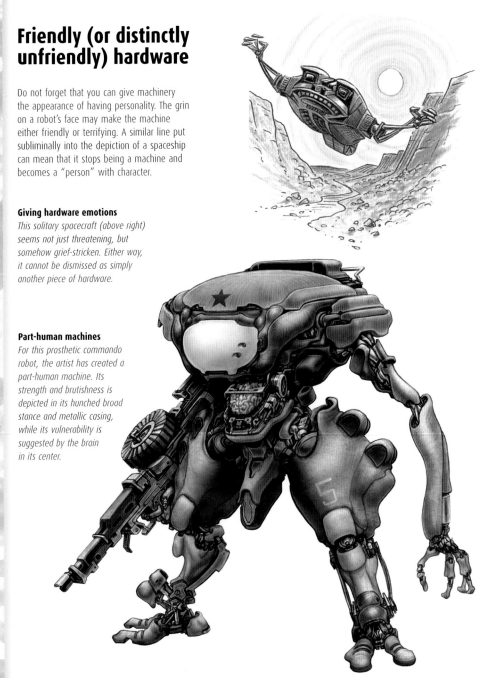

Giving hardware emotions
This solitary spacecraft (above right) seems not just threatening, but somehow grief-stricken. Either way, it cannot be dismissed as simply another piece of hardware.

Part-human machines
For this prosthetic commando robot, the artist has created a part-human machine. Its strength and brutishness is depicted in its hunched broad stance and metallic casing, while its vulnerability is suggested by the brain in its center.

Paradoxically, if you want to depict alien or fantasticated creatures,
the first thing you must know is how everyday creatures are put together.

Creatures

Whenever fantasy artists choose to depict a creature they must first think about the function of the creature's body. Physical forms evolve as a response to the way a particular organism can best function in its environment. Fantasy environments may be bizarrely different from those on Earth—for example, you might want to paint a creature that lives in the atmosphere of Jupiter, and so it must operate normally in three dimensions of movement rather than two. But most often the environments will not be that different. Take a unicorn, for example—this creature is likely to spend its time galloping across plains or roistering along river banks: the grass may be blue and the sky red, but essentially the animal is operating in an Earth-type environment.

Get hold of some books on animal anatomy—biology textbooks are as good as any. Do not just stick to the mammals: look for diagrams of reptiles, insects, and marine lifeforms as well. Once you see how the bones of an animal's skeleton fit together, and how the muscles overlay that skeleton, you are well on the way to being able to portray the animal in motion.

Creating the unknown
A striking viperfish from deep beneath the ocean's surface. Its powerful teeth and 13-foot (4-meter) body make it a fearsome predator.

Animal anatomy

In these sketches the artist has made preliminary studies of an ordinary horse before fantasticating to produce different images of mythological horse-based creatures.

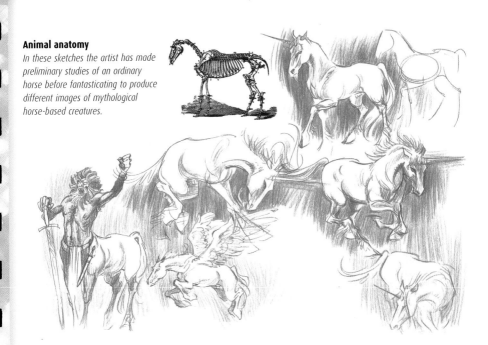

One foot in reality

The most convincing art is made by grounding the creatures with which you populate your fantasy landscape in reality—that is, making sure that, however fantastic in appearance, your creatures are functional in their own terms.

Fantasticating reality

In Martin McKenna's Unicorn Hunt *a Victorian safari hunting scene is transformed into a fantastical one through the unicorn and the triceratops-like creatures.*

Developing an alien creature

This sheet of drawings shows the artist developing an alien creature, with the emphasis on appositeness and plausibility.

Believable alien beasts
This dynamic saber-toothed tree cat has a similar pose and body shape to a lion, which is enhanced with fantastical elements.

COMBINATIONS OF ATTRIBUTES

Many of your fantasy creatures will not be so simply related to real animals. They are likely to combine attributes drawn from two or more creatures. Legendary monsters are often like this. The centaur is a mixture of man and horse. The gryphon has a lion's body but an eagle's beak and wings. The creatures you create are likely to display similar combinations. The creature devised by H.R. Giger for the *Alien* movies, even though made as otherworldly as possible, has attributes of humans, insects, crustaceans, and deep-sea creatures. Play around with elements of various different living animals and see how bizarre you can make the combinations. Always remember that the creature has to look as if it might function in some environment or another.

The anatomy of wings

A dragon's wing, like that of a bat or a bird, should be shown as an arm that has evolved into a wing: It should have the same joints as an arm. Think of the wings of a dragon as a built-in hang-glider.

The dragon

The dragon is one of the oldest mythological creatures. It has a widespread history, appearing in the traditions of virtually all countries and continents.

A dragon can be passive or aggressive, so the pose is extremely important. The form of the dragon is defined by its limbs, which can allude to the environment in which it lives—a water dragon, for example, may not need limbs at all. Other attributes, such as the neck length and whether it has wings or fire-breathing abilities, and so on, are the artist's personal choice.

The basic dragon pose

Use a symmetrical curved line for the dragon pose. Like a dinosaur, the tail counterbalances the head.

Dragons in action

In this cover for Michael Moorcock's novel The Dreamthief's Daughter *Don Maitz's winged dragon carries the hero to confront the Nazis.*

The good sword & sorcery artist has the power to make us believe again in things that we stopped giving credence to in childhood.

Sword
& sorcery

Often described by its aficionados using more "respectable seeming" terms like "high fantasy" and "heroic fantasy," sword & sorcery is the branch of the genre in which, typically, mighty-thewed, sword-wielding barbarians, aided often by Junoesque princesses, do battle with the forces of darkness, which are reified in the form of vile villains (often supernaturally assisted or endowed) and hideous monsters; wizards of various stripes are likely to take part on both sides in these titanic struggles, while the swords themselves may be possessed of magical powers of some kind.

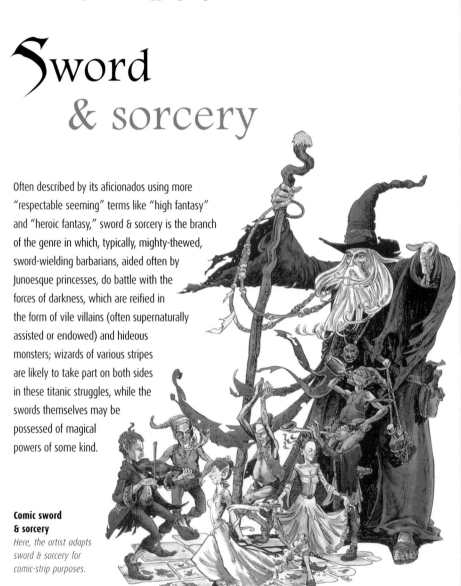

Comic sword & sorcery
Here, the artist adapts sword & sorcery for comic-strip purposes.

Written sword & sorcery

To understand sword & sorcery art, you really need some kind of feel for the written genre, so read some. All sword & sorcery stories tend to be set in what is, despite variations in nomenclature and other ancillary details, recognizably the same "fantasyland." The vast majority of these tales are—paradoxically within what is billed as a literature of the imagination—founded on well-recognized precepts and follow established rules.

Fantastical combat
Jonathon Earl Bowser's Master Pet *is a classic painting of the sword & sorcery subgenre: a diminutive warrior must fight a foe who is overwhelming in his size and ferociousness.*

A world of wizards
Good and evil wizards people the world of swords & sorcery. Janny Wurts's sorcerer in Wizard of the Owls *could be on a mystical adventure on this chilly misty morning.*

DEVELOPING CHARACTERS

Sketching is invaluable when formulating your ideas, as shown by this page from an artist's sketchbook. Clothing and adornments can help define your characters from the outset.

Ogre
The face requires a lot of work since this creature must be overtly carnivorous and vicious.

Wizard
Remember that conventions largely govern your depiction of sword & sorcery characters—there are no prizes for originality in this context. The cloak, beard, gauntness, and age all combine to say "wizard."

Parody

The subgenre, with its exaggerated characters and situations and its simplistic views of Good and Evil (note the capitals), is obviously open to parody, and many modern sword & sorcery works contain elements of arch self-parody (which is certainly an element you should think of incorporating in your art).

Portraying the conventions
Eric Lofgren's orc, the heavily armored creature poised for combat, represents the key elements of sword & sorcery.

A close relationship

Written and illustrated sword & sorcery are closely, almost inextricably intertwined: they draw on the same conventions and use the same visual imagery. History, myth, and legend are all brought together to create worlds in which all the characters are larger than life.

The role of the sword & sorcery artist is a particularly challenging one because the underlying tenets of the subgenre are so wildly exaggerated that the viewer's first reaction on encountering them is almost certainly going to be that this is nonsense. While one approach is to exaggerate even the fact that it is nonsense (to revel in the kitsch, as some artists gloriously do), the true challenge is to endeavor to make these scenes, and the characters populating them, seem—against all the odds—real.

Combining literature and art
Stephen Hickman makes a direct link with the literature of sword & sorcery through his painting Gaffer Gamgee and the Black Rider, *creating a dramatic visual scene from Tolkein's* Lord of the Rings.

In creating pictures that surprise, intrigue, and delight the fantasy reader—pictures that set the imagination afire—fantasy artists are constantly pushing out the barriers of the "normal."

Exaggeration

One technique the fantasy artist can legitimately use to excite the imagination of viewers is exaggeration. Some of the most effective fantasy art veers close to caricature. But, if it stops just short of that, the exaggeration can convey to the viewer a lovely "feel" of fantasy. The exaggerated muscles on almost anyone's depiction of Conan the Barbarian might be physiological impediments were he to be a mundane man, but in the context of a sword & sorcery scenario they seem plausible. Similarly, an artist might depict a parodic barbarian who wears a belt adorned with such a weight of edged weaponry that the character would, in reality, be barely able to stand, yet the arrangement is perfectly acceptable within its imaginative world.

Oversizing
The artist grossly exaggerates the hardware of the warrior (above).

Positioning and cropping
In exceeding the picture space and the up-shot view the beast has tremendous force (right).

Don't be frightened to exaggerate!

You could draw a Rambo-style, muscle-bound hero as small and wimpish, but is that really the image you want to convey? Much better, surely, to make him huge and covered with weapons! Make his muscles vast (especially those of the shoulders and arms); give him so many weapons he could hardly stand up if he were to be carrying them in the real world.

While working up the preliminary stages of a character in your sketchbook, you can give him all the crazy attributes you want: later on, you can tone them down a bit, but for the moment enjoy the exaggeration.

Parodying the superhero
In Doc vs the Martians *R. Stephen Adams creates a muscle-bound hero whose brawn is juxtaposed against the alien spaceships landing in the heart of America.*

Exaggerated authority
The exaggerated proportions of the man and his weapon are ideal for the battle-orientated fantasy world of Howard Lyon's Deepstone Sentinel.

All the best fantasy art has a sense of movement, of storytelling.
Nowhere is this more so than in comic-strip illustration,
where the artist has an overt storytelling function to perform.

Comic strips

Almost all forms of fantasy art are narrative art. Often, if you look at a good fantasy painting, you will see that, even though it depicts just a single scene, that scene implies two stories: the one preceding the scene and the one following it.

Storytelling

A story is not just the recounting of a series of events. Stories have structure-narrative form. They have a beginning (characters and scenarios are introduced), a middle (a number of interconnected events), and an end (satisfying resolution). Your strip succeeds if the reader identifies with one character or group and "lives" the story through them. Make sure he or she is carried along from one event to the next. Every frame should lead the eye on to the next frame.

There is certainly room in comic-strip art to do bits of fancy painting and drawing, and to let your imagination take flight, but never do this at the expense of the basic job: storytelling.

Developing narrative
This story began with a "dark man" who could "spit lightning from his eyes." These sketches show how the image was created. The artist was given a free rein to develop this scenario.

Definitions

Each picture in a sequence is called a frame; the narrow spaces between frames are called gutters. Dialogue is contained in speech balloons and thoughts in thought balloons. Narrative text is generally contained in panels and sound effects ("FX" or "fx") are usually lettered in a suitable style within a frame.

The script

Some comic-strip artists do it all themselves, but most strips involve at least two people: a writer and an artist.

Your script will have a standard, frame-by-frame format. For each frame you will be told, first, what it is that the picture must show: this will be both a description of the scene and, possibly, a few words explaining how the picture advances the story. Next you will be given the wording (if any) for the narrative panel and for the various characters' thought and/or speech balloons. You may also be given some FX to incorporate.

Comic strips should be thought of in a similar way to a film (see overleaf). The way in which the artist advances the story in each frame will influence the response of the viewer. The angle-shot above slightly disorients the reader and can add shock-value.

DEVELOPING A CHARACTER

When you first get a script, the writer's description and the personality that a character projects will give you ideas as to what that character looks like. Do lots of sketches of the character in different poses and performing different actions, bearing in mind the poses will also express personality.

Here, through repeated sketches, the artist experiments with different representations of a character.

SHOTS

Like a movie director, be aware that the distance from which you view something—each "shot"—affects the reader's emotional reaction to that part of the story. Over the story as a whole, your choice of shots can entirely transform the reader's concept of the tale.

The long shot is often used as an establishing shot to orient the reader when there is a change of scene, or a shift in the viewpoint from which the tale is being told. It can also be a mood-setter rather than merely a scene-setter.

A general view conveys the positions of characters and their surroundings.

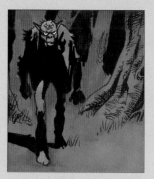

The medium shot can be an action view or a mood-setter.

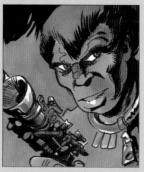

Use the closeup when you want readers to identify with one character.

Ultra-closeup is used to accentuate the emotion of a single character.

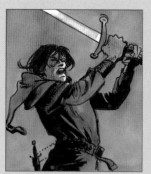

The up-shot makes the figure more impressive and can add menace.

The down-shot renders the reader a voyeur—someone watching.

Artwork stages

In doing the rough layout you are deciding how much space to give each picture, how the pictures fit together, and the relative prominence each should have. The shapes in the page's composition must lead the eye, linking one piece of lettering with the next.

An artist's rough developed from a script.

Finished black and white artwork. Don't start it until you have solved all the problems.

Read the script through carefully to see how best you can tell this story. Does it require delicate, decorative line drawing or dark dramatic shadows? You should think about how big and how small you want the various frames to be, and about how you want them laid out on the page: would they be best all roughly the same size and placed in neat rows, or should one be far bigger than the others, dominating the page? Bear in mind that your page layout sets the tone of the story. Should the reader be allowed to follow a simple ordering of the frames, or should there be a more complicated pattern of visual events? Remember you must give the reader enough information that he or she can follow the story.

Look out for the story elements—the crucial scenes, the significant characters, the relevant hardware. Imagine the script was for not a comic strip, but a movie: what would that movie look like? Try to visualize everything in motion.

Keeping it colorful
Your use of color need not—and likely will not—be naturalistic. Here, the artist has chosen the colors for the emotional punch they can deliver. This page is doing a lot of work, setting one scene and then launching the characters toward another. This transition is important—hence, the great force and movement given to the final picture.

You can add visual and emotional impact to your fantasy work by inventive use of lighting, but first you must be aware of the conventions whereby lighting is used in orthodox art.

Lighting

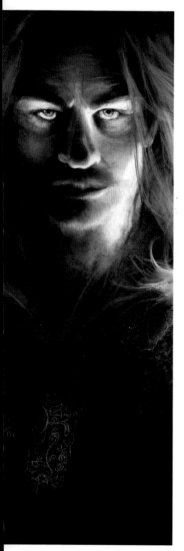

Light normally comes from a single source. The position of that source in relation to the various elements of the picture determines, for example, how shadows will fall and how facial features will be illuminated. Unless the light source is placed somewhere unusual (say, directly overhead or directly underfoot), everything in the picture will be more brightly illuminated on one side than on the other. There are various other rules of a similar sort, and it would be worthwhile studying how other artists handle lighting in conventional and fantasy art.

Edge-lighting

You can convey the same sense of drama and forcefulness—and often with greater subtlety—by edge-lighting the central images. Under this process it is assumed that your source of illumination is positioned so that the salient edges of the object are picked out with light, while the rest of the object is mysteriously murky.

Dramatic lighting
Mike Nash evokes a powerful unsettling character for his portrait of Dracula by the light striking his face only, leaving the rest of his hair and clothing in the dark.

LIGHT SOURCES

The way that lighting falls across a face can determine the way we perceive personality and expression. It is a useful tool therefore to develop mood and temperament.

1 Two light sources give the face a more sensitive look.
2 Light from above sinisterly deepens shadows around the eyes.
3 Uplighting can be relied upon to produce a sinister look.
4 Light from the side delineates features to emphasize character.
5 Light from the near side gives a starker portrayal.
6 Edge-lighting can be used to emphasize dramatic effect.

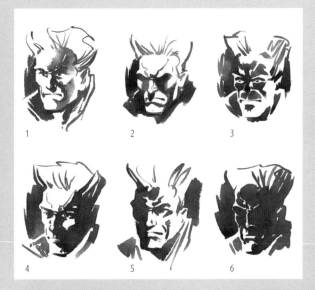

Silhouettes

An object lit entirely from behind will appear as a totally flat shape, so if you want to use this form of lighting you must make sure that the silhouetted object has an interesting outline. Think about the angle from which you want to show the object; the same spaceship can look like a meaningless blob from one angle, but take on an impressively threatening, massive form if seen from another. Silhouetting can be immensely exciting, giving objects more "presence" than other, more orthodox means of portrayal.

Adapting conventions
The silhouette of the wolf develops tension in Chris Quilliams's painting Spirit of Wolf.

Artificial lighting

In silhouetting and edge-lighting, it is assumed there is just one source of light. For maximum contrast and dramatic punch, single-source lighting is the option to choose, but you should play around with your lighting effects, and bear in mind that the kind of lighting you choose has a profound effect on the emotional response the image generates.

Normally, of course, the single light source is the sun—or, more accurately, the illuminated sky. Natural light is not always the best for fantasy art, as it gives a more diffuse effect than you would normally want. Most often the lighting purports to be natural but is in fact artificial, creating dramatic effects of light and shade.

Always remember that light and shade are tools you can use, so place your patterns of light and shade wherever you think they will best enhance your picture idea and give it emotional undertone or dramatic impact.

Light and the fantasy world
In fantasy art dramatic light can come from many sources such as the shot of fire from Jon Hodgson's dragon.

Light and color

Altering the color of elements of the natural world your viewer will be familiar with is a fundamental way of playing with their emotions. And so is the strength of line and modeling you use. Experiment with different strengths to see how they affect the emotional interpretation of your picture.

Developing impact
The modeling of the hardware and rocks in the foreground enhance the brutalness of Kieran Yanner's War.

ALIEN LIGHT

The lighting on different planets on which humans could live cannot actually vary very much, but viewers will expect scenes set on distant planets—or in fantasy worlds—to look different, however much the shapes in the picture might be the same.

In order to convey this effect, we use the deployment of subtly "wrong" color schemes. You can, of course, use completely false coloring—green skies and so on—but, to give a scene alien light, it is usually more effective to add subtle extra hues into the ones the viewer would normally expect to see.

An even subtler way of attaining such effects is to play around with the shadows. Giving everything two shadows would convey that there were two suns and hence a dual light source. Or, try making all the shadows glow in an unfamiliar way—so that they look neither gray nor blue-black but instead some other color, possibly quite a bright one. Alternatively, you could make them completely black and very sharply delineated, conveying that there is something very peculiar and otherworldly about the lighting here.

One way of playing around with alien-light effects is to use the inadequacies of the color-photocopying process or experiment with painting software. Draw and paint a scene in normal lighting and then have a color photocopy made of your picture, or change the colors digitally. The new appearance of the lighting is almost certain to give you a fresh insight into ways to add unearthly light into your picture.

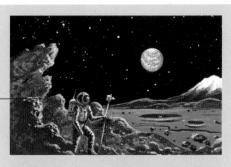

Crisp hard edges indicate lack of atmosphere.

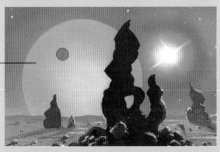

Two light sources create a complex pattern of shadows.

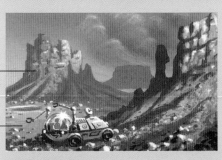

Clarity of distant objects indicates the atmosphere is thin.

Overall color values show this is an alien world.

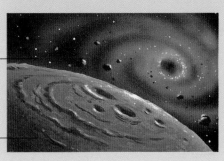

Pattern of light across surface shows there is no atmosphere.

Shadows are pitch black because no atmospheric refraction.

If you are to imagine and draw the products of future technology, you need to have some awareness of where technology is now.

Hardware

By "hardware" we mean hard-technology art—the depiction of the hi-tech. This is the kind of art usually associated with science fiction and technofantasy: it is characterized by clean edges, the appearance of huge sculpted areas of metal, the right-seeming "aerodynamics" for spaceships, and so on.

Think about the functions your pieces of hardware have to perform. In Arthur C. Clarke's book *The Snows of Olympus* (1995), there are two pictures of future farms on Mars: one was drawn in the 1960s and the other in the 1990s, but there are more similarities than differences between the two pictures. The reason is that the two artists thought about the same problems and "solved" them in similar ways.

Cossack motorcycle
Although the design constitutes a different take on relatively preexisting technologies, a clunky, industrial feel is exaggerated throughout, from the throwback gun to the large studs coating thick plates of metal.

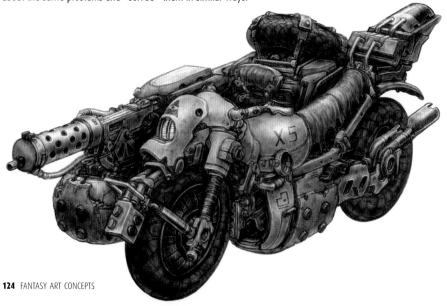

Space hardware

In Kieran Yanner's UC Shipyard, *fragments of the monolithic spaceships appear, but we get a sense of their size with the juxtaposition of the spacejet (lower foreground).*

Futuristic car

The artist combines real-world items to produce a futuristic car. It is basically a 1937 Ford with steel-plated wheels, supercharger, roof-mounted M60 machine-gun, wing-mounted L7A1 GPMGs, and chrome spikes.

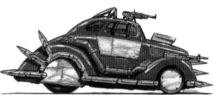

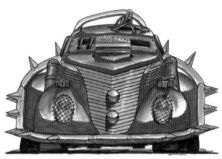

RENDERING IN VARIOUS MEDIUMS

Before tackling the final artwork, you need to think about which materials you will use to create the surface effect you want, and probably try a few experiments.

In this image the artist plays with (from left to right) pen-and-ink stipple, gouache applied with a brush, and airbrush with additional application of gouache by brush for the linework.

FRAMES AND VIEWPOINTS

In *Terminator 2: Judgment Day* (1991) the good robot, Arnold Schwarzenegger, retains a basically human form almost throughout. There are two ways we are constantly reminded that his character is a machine. One is the machine-like delivery of his lines. The other is a visual trick. On occasion we see events through his machine vision, with items of data scrolling rapidly on the screen and, as significantly, with scenes being shown in leached colors and with the focus swooping dramatically to and fro. The impression of hardware is excellently conveyed by this quite simple stratagem.

You can catch an analogous hardware "feel" by reverting to a style that has much in common with engineering drawing, where some of your lines are drawn the way they should be rather than to represent what the scene would actually look like. Allied with this, you can use odd frames and viewpoints, again taking your inspiration less from conventional art than from scientific diagrammatization.

Alternative viewpoints
In Kieran Yanner's Lonestar *(below) the blue diagrams suggest we could be looking through a machine's eyes.*

Built for war
This M24 Hausen robot harks back to World War II US assault craft.

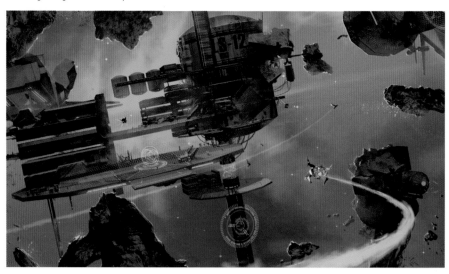

You—the inventor

In hardware art you, the fantasy artist, become something more than an illustrator: you become an inventor. Hardware creations arise through a lot of drawing, redrawing, enhancing, adding, and adapting. Fool around in your sketchbook until you feel you've invented something good. Hardware surfaces can be gleaming, smooth, and machined, or they can have a patina, be weathered or decayed. Experiment with hardware surfaces until you feel happy with them. To give them shape, you could use surface markings like letters and/or alien glyphs. This is the approach the French artist Moebius used in his initial sketches of the colossal derelict spaceship that is encountered early in the movie *Alien* (1979).

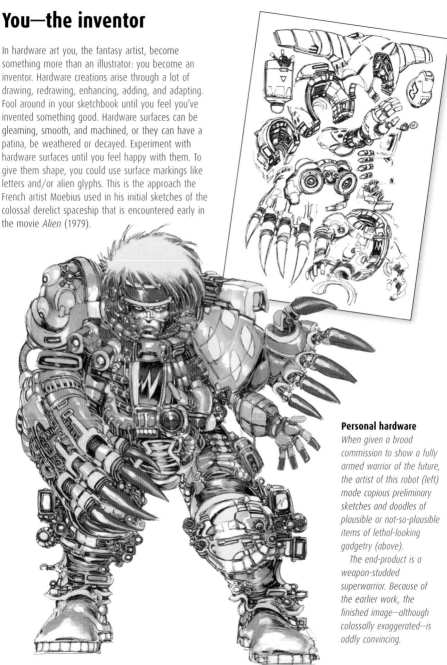

Personal hardware

When given a broad commission to show a fully armed warrior of the future, the artist of this robot (left) made copious preliminary sketches and doodles of plausible or not-so-plausible items of lethal-looking gadgetry (above).

The end-product is a weapon-studded superwarrior. Because of the earlier work, the finished image—although colossally exaggerated—is oddly convincing.

Some of the tricks used to create an illusion of depth and space involve those of conveying massiveness, but most are concerned with perspective.

Illusion of space and depth

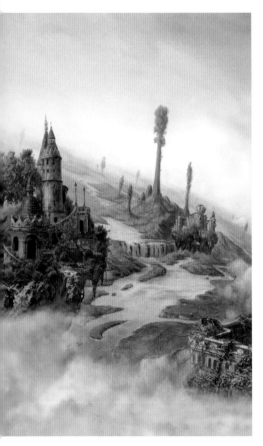

A typical fantasy-novel cover—almost a cliché of the genre—shows one or more tiny figures in the foreground and, behind them, a landscape that seems to recede into infinity, with huge mountains reaching up almost to touch the sky, or vast plains that look as if they might go on forever. The overall impression is that the background is built on some scale vastly more huge than the human.

Aerial perspective

When we look at a real scene, our perception of it is affected by the color values of the various elements. Refraction in the atmosphere causes changes so that more distant objects—the classic example being faraway hills and mountains—look blue or purple even though they are really just as green as nearby ones. The focus is less sharp than on foreground features, so that you can see little details and tonal contrasts become more muted, so that there is little apparent difference between light and dark colors. This is known as aerial perspective. By exaggerating aerial perspective, you can make distant objects seem almost impossibly far away.

The fantasy world from above
Rob Alexander depicts an infinite river-filled landscape in his striking image Aerial View.

PERSPECTIVE IN SPACE

Of course there's no aerial perspective in space, but you can still use the trick of muting the tone and color contrasts. More distant objects (like spacecraft) can be indicated this way, with all their colors tending toward the background color—black in reality, but often you depict space in some other color.

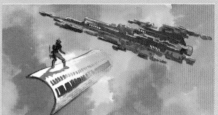

This drawing (above right) creates the illusion of vastness through linear perspective and the positioning of the looming craft above more human-scale objects.

Often you depict space as colored, which is green in this picture (right). Thus distant objects appear greener (that is closer to the background color).

Linear perspective

The basic law of linear perspective is that things appear smaller the farther away they are. Spaces between objects become smaller, too, so that lines (usually adjacent features) on distant objects tend to run together, becoming too small to be discerned as separate. Thus you should use fewer lines for more distant objects and make the lines finer. The law of diminishing size sounds simple—and

indeed is—but often objects are not all the same size in reality. If you have two asteroids, one ten times the size of the other but twice as far away, the more distant one would still look bigger than the closer one. So you have to combine elements of both kinds of perspective—aerial and linear—or perform a "con trick" by pretending the objects are roughly the same size, so that distant ones

look naturally smaller than near ones. Then make a few of the more distant ones a bit bigger to reflect their larger size.

Alien perspectives

On Earth the atmosphere is fairly transparent, but this need not be so on other planets. Venus' atmosphere has such a high refractive index that the horizon curves toward the sky. The gases in the Jovian atmosphere are colored, lit partly by the planet's own energies, and is unimaginably turbulent. Try playing with the aerial-perspective effects you would experience in such situations.

Perspective tricks
In Alan F Beck's Le Passage *the sea recedes into the sky, yet in the foreground it tips out of the painting.*

There are various ways in which you can play with the natural perspective of a picture to create a puzzling or intriguing effect— to give the viewer a displaced feeling.

False perspective

In order to give apparent depth to a picture, we normally use the convention of linear perspective. The farther away an object, the smaller it appears. The apparent diminution is linear: it can be formalized and made plain using the conventions relating to positioning and to the vanishing point on the horizon to which all the perspective lines point. But you can use this perspective the other way around to show that a scene is not what it seems.

Use curving lines rather than straight ones to establish positions and forms within your picture. Remember to be consistent when playing with perspective: conventional linear perspective, the form normally used in illustration, is designed to fool the viewer into believing that the flat, two-dimensional page shows a three-dimensional scene. Remember, when using conventional perspective you are asking the viewer to enter into a contract with you: that he or she will accept the perspective you use as a fair description of the reality. As soon as you start fooling around with that convention, you are asking your viewer to take a further step.

Bending perspective
In this colored drawing the artist chose to disorient the viewer by adhering to the rules of conventional perspective, yet replacing all the straight lines with arcs of a circle.

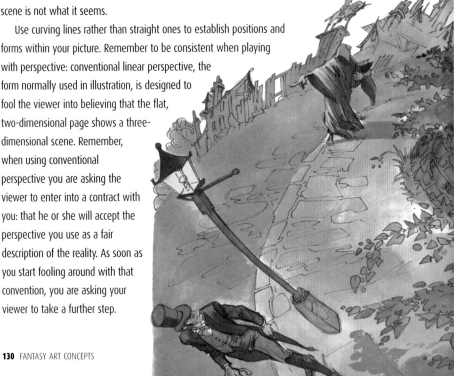

CONVENTIONAL PERSPECTIVE

In order to manipulate false perspective, you need a full understanding of the rules of conventional perspective. This is useful anyway, because in many of your fantasy paintings you will wish to follow these rules.

1 Single vanishing-point perspective *deals with only one set of planes, thus giving the two-dimensional picture depth in only one direction.*

2 Two vanishing-point perspective *is the form most commonly used. Each set of planes has its own vanishing point.*

3 Three vanishing-point perspective *is used when you want to create the illusion that something is of great depth or height. The verticals slope to meet at a high vanishing point.*

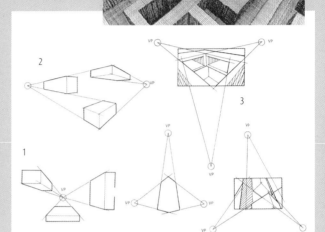

Playing with perspective

This is a means of disorienting the viewer, giving a sudden jolt of "otherness," so that even mundane scenes can become indefinably strange. The thing to remember is that conventional perspective is itself a trick, a mere illusion, yet we accept it unquestioningly as if it were providing a true portrayal of depth. Any distortion of it is likely to disorient the viewer.

Strange perspective
The perspective of Randy Gallegos's Mosquito Guard *creates added drama.*

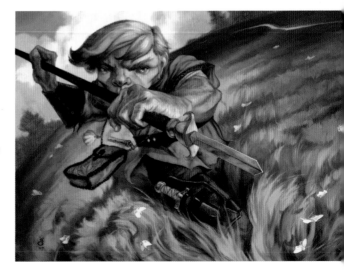

One of the great joys of fantasy art is that it frees you from the constraints of reality, but this does not mean that you can discard all the rules.

Impossible structures

Most of us will have seen the structures created by the Dutch artist M.C. Escher. A channel of water runs uphill to a waterfall that feeds the bottom of the channel; a stairway looks superficially normal but is in fact neverending, leading nowhere except back to itself. Such structures are impossible. Nothing like them could exist in the real world, but they create, at least temporarily, an illusion of reality. However bizarre the edifices you create, they must still look convincing. Escher's neverending stairway is effective just because the stairs themselves look so real.

Tree cities
In this drawing of tree cities, anthill-type dwellings top plateaux formed by the branches.

FANTASY ARCHITECTURE

Creating implausible and impossible structures is a kind of conjuring trick—viewers realize that the structure could never exist, yet can imagine dwelling inside it. One way of doing this, as displayed in the picture on the opposite page, is to give surfaces, lighting, etc. a super-realistic treatment.

Making it real
The organic city (right) seems to take fungi and gourds as its inspiration. Lots of little details combine to make the image convincing; the use of perspective tricks (notably curved lines in place of straight ones) increases both the fantastication and, paradoxically, the plausibility.

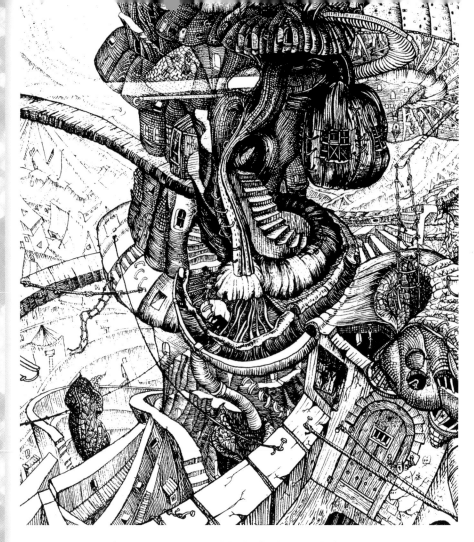

But, while tipping your hat to structure, you can safely abandon the practical rules of architecture, depicting, for example, towers several miles high, but only a few tens of yards wide at their base; edifices that float in midair; large decorations embellishing relatively small buildings; remote extensions that could be reached only by flying creatures; or castles the size of mountains. You could also experiment with architecture based on living organisms like trees which would need to be in a constant state of flux because the trees would be continuing to grow, or buildings constructed on the back of a creature, or on the head of a giant.

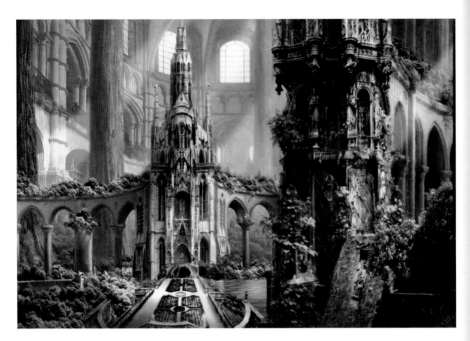

Reality corner

But there must always be an element of the structure that keys in to the viewer's knowledge. One way of achieving this is by introducing bits and pieces of known architectural styles, or architectural elements we commonly see in everyday structures. The Gothic style is the one that fantasy artists most frequently call on—it is immediately recognizable as well as having an inbuilt fantasy feel.

A useful structural element to keep in mind is the flying buttress. Patch a few of those onto your edifice, plus the occasional Gothic arch, and you will convey the impression that this building just might be structurally sound, while also giving your viewers a reference point whereby they can interpret the thing you have painted.

Another stratagem is to introduce human (or at least human-oid) figures to your painting. This has the added advantage in helping to convey a sense of scale. However fantasticated the place they live in, people have certain basic needs. You have to have windows so that light can enter the building; people require running water—and, of course, toilets—so think about tacking on a few elements that would seem to cope with these requirements. You can make these additions as baroque as you like; they need not be truly functional or even specific as long as they create the impression that they are there for some function or other.

Introducing some reality
Although the setting in Rob Alexander's Temple Garden *is pure fantasy, the architectural features are recognizable from the real world.*

City of the future
In the picture opposite the artist has used linear and aerial perspective to convey the colossal heights of the skyscrapers in his futuristic city.

HEIGHT AND VASTNESS

These are often the keys to the implausibility of an architectural structure. Don't be afraid to make your buildings miles high or so vast that they would require a good internal public transportation system to traverse them.

Exaggerated structures
The positioning and vastness of the building in Paul Bielaczyc's Wizard's Academy *(right) evokes its special magical qualities.*

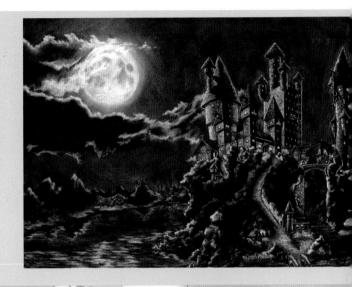

Written fantasies often call the precise nature of reality into question, seeing the reality in which we live as no more than the superficial manifestation of what existence really is.

Alternate
realities

Collage of realities

In this lively piece, the artist has mixed collaging with scale differences.

Behind the manifestation of reality, there may be a whole welter of other realities lying parallel to ours—perhaps the reality that lies on the other side of the mirror.

An obvious example of an alternate reality is fairyland, which since the earliest legends has been regarded as a world that co-exists with ours, to which we can hope to gain access through magic or special techniques. More recently, science-fiction writers have adapted this idea to that of parallel universes, resembling ours but separated from it by some change caused by past events. The artist can recreate—and extend—the feel of such stories to show what it would be like if we could see through the surface of our reality to the more exotic territories behind it. You can also overlay incidents that, although belonging to a single reality, are widely separated in time and/or space, to create a juxtaposition that is physically impossible but conceptually quite natural.

JUXTAPOSITION

Realities can be separated out within a single image by giving them different scales and different theme colors, as demonstrated in this color sketch.

Looking into someone's mind? Well, here's a crude way of doing so—an engineer's cutaway drawing of the person's thought as if their mind were a house. What goes on in this house's rooms varies radically depending on the type of person you're depicting: a painter's "rooms" will be quite different from those of a soldier.

Merging Earth and space
The strange land that these explorers are climbing in is the moon rather than the Earth's mountains in Martin McKenna's Moon Explorers.

COLLAGING REALITIES

At the most basic level, you can create such juxtapositions using a collage-type arrangement, which is what movie posters often do.

The idea is to integrate the various "shots" pictorially, while making sure that they are perceived by the viewer as being separate. There are various devices you can use, such as employing wide diversities of scale, and lighting each of the shots differently. As a general rule, use bright front lighting for the shot that you want the viewer to regard as the base reality.

You can either keep the different lightings rigorously separate or grade them into each other. You can also try giving each of the shots a different theme color, which directly conveys to the viewer that the shots are set in different realities.

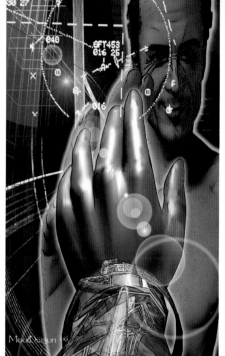

Here (left), the artist has used differences in scale to separate the realities.

Below, the artist has overlaid different realities, reading from front to back.

Layering realities
From front to the back, Bob Hobbs layers human and mechanistic elements in Stringing Tomorrow, taking the viewer deep into a futuristic world.

VISUAL PUNS

Many of the expressions we use in everyday speech can be used as bases on which to build pictures that overlay conceptual realities. We talk of people having butterfly minds—so what would it look like if someone's mind really were a butterfly? Or we say someone is hagridden—which you could literally interpret to show them with a witch riding on their shoulders. Or we talk about someone's flesh crawling...

In all such instances, the visual realization of the verbal expression forces the viewer to do a double-take—to "solve" an initially confusing visual image.

One way you might kick off an alternate-reality painting is to begin as here (above right), with something so prosaic that it is hard to imagine any kind of "ethereal presence" behind it. A can of beans, for example...

How big is a can of beans?

It can be as big as you want it to be. One popular fantasy idea is concerned with huge discrepancies of scale, so why not make your can of beans really huge? It is now a massive structure in which countless generations of relatively tiny people can be born, live out their lives, and die. There could be wars going on in there!

Exceeding expectations

If you look into a real can of beans, you see...beans. But here lighting is used to convey that there is something quite other in the can.

The object of much fantasy art is to "displace" viewers from the mundane world by giving them clear signals that what they are looking at is in some way definitely other.

Displacement

You are aiming to lift the viewer from the ordinary into the extraordinary. Often this is no particular problem: if you are showing a scene full of dragons, the viewer needs no further clue that this is not something taken from the real world!

The technique of displacement, however, is much more subtle than that. You present the viewer with a picture that seems, on the surface, completely mundane, and yet the viewer is aware from the outset that there is something wrong with it—something other. One or more elements of the picture have been displaced away from the mundane. M.C. Escher was a master of displacement: many of his pictures seem perfectly normal at first sight, but a few seconds later you realize that the structures or events they portray are impossible.

Displacing expectations
In R. Stephen Adams's Tourists, *three figures stand before us as if on holiday, but rather than posing by a natural phenomenon, such as the Grand Canyon, they are in a strange spacescape.*

Try doing some sketches from life and introducing to them some out-of-place element. If you are waiting for a train, do a quick drawing of the other people standing on the platform, but add something of your own invention to make the scene bizarre. Be as subtle as you like: a line or two may be enough to create the sense of unease, of oddness, that you are trying to capture.

One way of achieving displacement is to present a mundane scene in which the viewer notices something distinctly wrong after a while. Below, three artists approach this notion from the same starting-point—a rail station—and offer three very different displacements.

Floating commuters
In this sketch (top right), all seems normal until you spot the commuters are floating above the platform.

Stange beasts
Here (middle right), predatory-looking machines line the station platform.

Catching the train
In this station (right), trains stand on the platform waiting for a human to clatter in.

One of the standard techniques of fantasy art is to turn something mundane into something otherworldly by using an odd angle of observation.

Distortion
of form

Curious and intriguing effects of foreshortening are created by rendering scenes from odd angles. People standing in a line in a store would look really weird if you were lying on the floor and looking up at them—hugely enlarged legs, tiny heads, etc.

The idea of distorting form is related to this, but with a major difference. Instead of looking at something (say, a person) from an unorthodox angle, you create an even greater oddity because there is no visual cue to the viewer as to why some parts of the subject are grossly deformed by comparison with others.

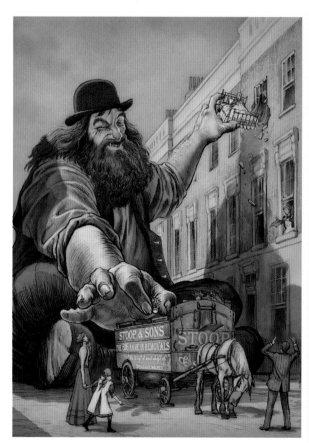

Removal Giant
By making the viewer look at the giant from below, Martin McKenna increases the incongruity of the scene.

MORPHING

One of the most popular special-effect movie techniques is morphing, which involves using computer-animation techniques to give objects (usually people) impossible shapes. Part of the excitement of movie morphing is that the images are in motion, but a static form of morphing—really an imitation of morphing—is an integral part of much fantasy art. Some of the effects you can achieve by distorting forms are very obvious, but others can be much more subtle, and convey an otherworldly feel precisely because the viewer does not consciously realize you are using them.

For example, the legs of an elemental creature in flight might be such that it would be impossible for it actually to stand up. The viewer does not consciously realize this, but nevertheless gets the subconscious input of otherworldliness. Some classical painters, notably Titian, used this idea when depicting mythological or biblical subjects.

Distorting on a grid

When distorting a form, it is best to do so in a consistent fashion. One way to do this is to place a rectilinear grid over an undistorted version of the picture, then twist or bend the grid.

Bizarre foreshortening

These drawings (above and right) show strange, even unsettling, distortions of perception by exaggerating the effects of perspective.

The juxtaposition of diverse objects is one of the fundamentals of art, the basic principle of both the still life and collage.

Juxtaposition

In fantasy art, outrageous juxtaposition is an important tool for creating an effect of otherworldliness: the items you choose to juxtapose are taken from such divergent sources that there is no possibility of their being found together in the real world. The effect is one of surrealism. Unfamiliar juxtapositions have the effect of jolting the viewer's expectations and imagination and, since a purpose of fantasy art is to haul the viewer out of this world into another, a way of attaining this "feel" is to juxtapose things not seen together in everyday life.

Visual metaphors
Bringing together the girl with the American Tree Sparrow creates an enchanting metaphor in Patricia Ann Lewis-MacDougall's image Prudence.

A CHICKEN ON A BICYCLE

Anyone can throw together a collection of disparate objects: the result may convey that true fantasy "feel," but more often it will not. The trick is to make your portrayal of this bizarre scene as naturalistic as possible.

Taking the effect further is a matter of technique—pure and simple. All the techniques you would normally use to convince a viewer he or she were looking at a completely naturalistic scene—uniformity of lighting, correctness of perspective, shadows, and so on—must be brought to bear to create the illusion that your picture is of a real situation, even though it might be of a chicken riding a bicycle! Paint the chicken as though it belongs on the bicycle and the bicycle as though it belongs under the chicken—and both of them as though they belong in an average city street.

Always remember, though, that there are two components to an effective piece of bizarre juxtaposition. One is visual: you are putting together objects or people who could never be seen in such proximity. But the other component, and the more surreal one, is conceptual: you are throwing together ideas that in the normal way should be totally unrelated. This is what a lot of the best written fantasy is about, and there is no reason why you should not attempt to emulate that conceptual inventiveness in your art.

A city of paradox
The drawing above contains countless juxtapositions of genres and different historical periods.

Lincoln in space
In Zombie Lincoln, *not only does Frank Wu juxtapose Abraham Lincoln with space, he also places him in incongruous clothing.*

4

Gallery

Feathered Foe
Janny Wurts

Sword & sorcery

In this world of adventure, heroes and beasts are often larger than life as they fight battles and wield magic against the forces of darkness, while elements of tales and legends are combined in dramatic scenes peopled by barbarians, monsters, wizards, and warriors.

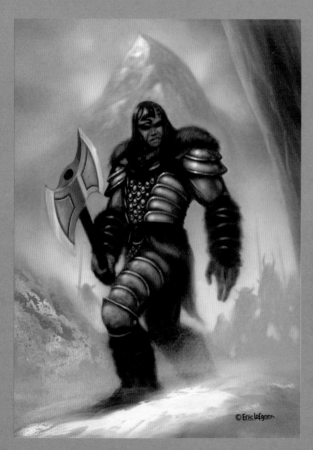

Out of the Frozen Wastes *(left)*
Eric Lofgren

The exaggerated proportions of this hulk of a warrior emerging out of the snow-laden mist is ideal for this area of heroic fantasy. The low positioning of the viewer, as if possibly hiding by the base of rock to the right, and the detailed painting of the warrior's armor heightens the effect.

Silence *(right)*
Ruan Jia

Ruan Jia developed this image to portray a prince who journeys into another land in search of a magical weapon described in a legend. He is a solitary adventurer in a mystical place, yet the light radiating from his face and ornamented clothing endows him with a magical quality.

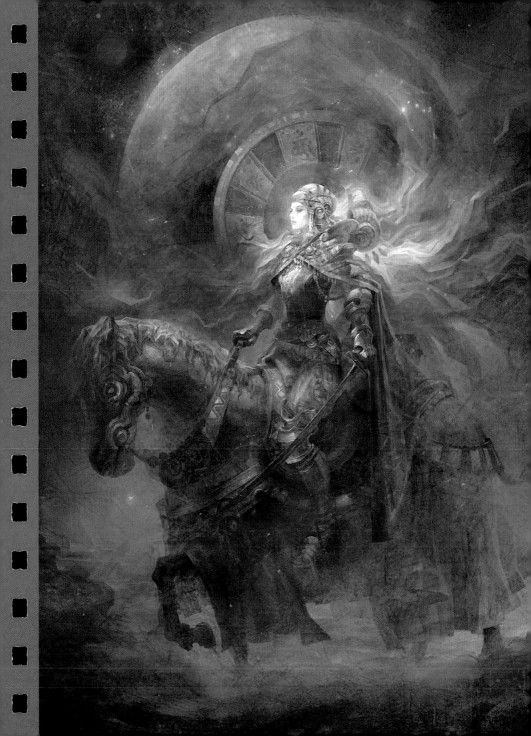

Private Investigator *(right)*
Scott Purdy

Scott Purdy's *Private Investigator*
can be seen as a contemporary
working of sword & sorcery. Purdy
cleverly plays with the viewer's
perceptions through the unsettling
nature of the immense goblinoid
figure, dressed in a hat and coat:
the uniform of the private
investigator who fights against evil.

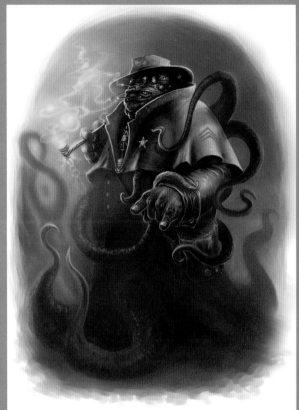

Token *(left)*
Chris Parsons

The knight is almost overwhelmed
by the massive metallic structure he
stands atop and the dramatic sky,
taking the scene out of the real
world into fantasy. Yet the token he
releases grounds the figure in the
historic tradition of medieval
knights, and points to a human
story in this strange world.

Dark Knight *(right)*
Jonathon Earl Bowser

The knight traveling alone by the
light of the moon is more firmly
set in the human world than is
sometimes seen in high fantasy,
yet the golden reflections in the
pool suggest he and his horse
possess enchanting qualities,
promising adventure to come.

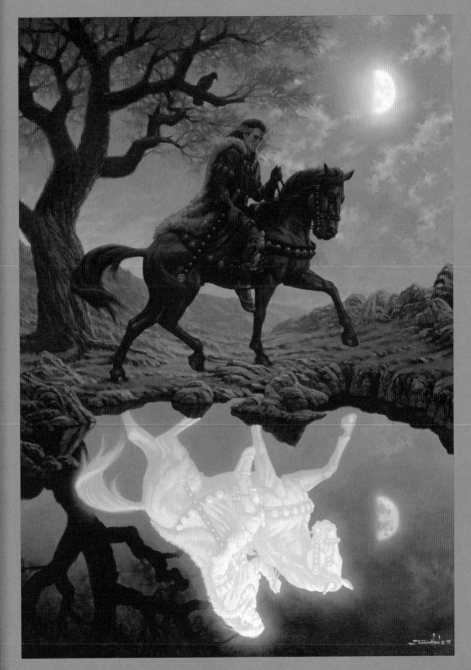

Tracker *(left)*
R. Stephen Adams

Working in digital mediums, R. Stephen Adams creates compelling paintings with a photo-realistic quality that combine diverse elements and offer highly original interpretations of classic fantasy themes.

The Harp of Galadriel *(right)*
Stephen Hickman

Painted in oil on canvas, Stephen Hickman's painting invites the viewer into the rich fantastical world of Tolkein's *Lord of the Rings*. The finely dressed figure in the foreground playing the beautifully carved harp dominates the painting, yet a glimpse is offered of a passage through the wood beyond.

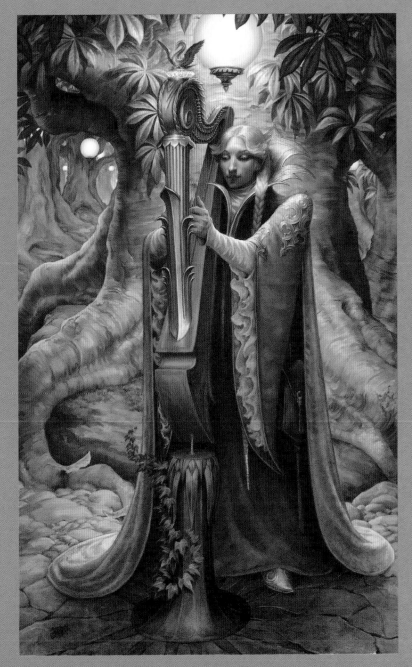

Enchantment

The world of enchantment—fairies and ephemeral spirits—has long attracted artists to the magical possibilities in nature around us. It is characterized by a delicate touch yet offers fantasy artists wide scope in all mediums.

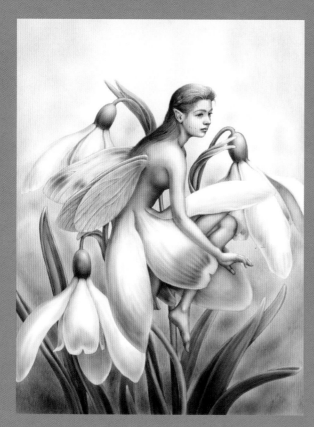

Snowdrop *(left)*
Minae Takada

Working digitally, Minae Takada creates a gentle image of a fairy who almost seems to grow out of the petals of the snowdrop. The subtlety of the image is enhanced by the soft tones of green and white, and the restrained detailing of the petals and wings.

Alar 5 *(right)*
Vanessa Gaye-Schiff

Vanessa Gaye-Schiff creates her beautiful images by digitally painting and adapting photographs. She starts by deep etching all the elements that will appear in the image, and then applies up to 70 to 80 layers of highlights, shadows, overlays, and different opacities.

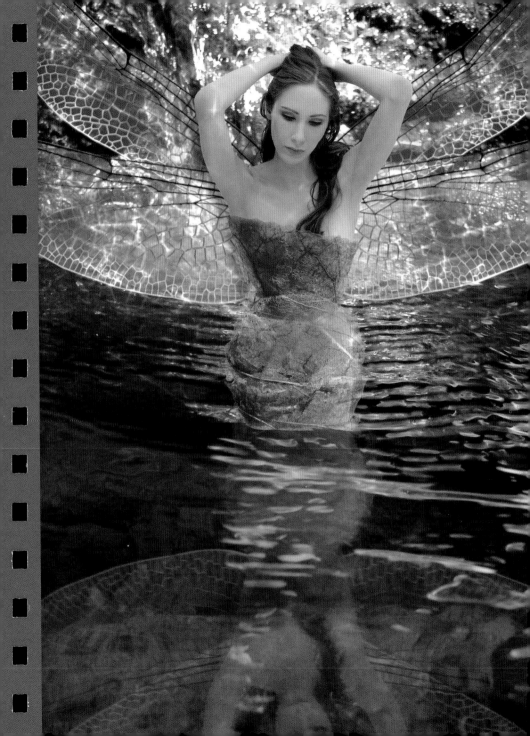

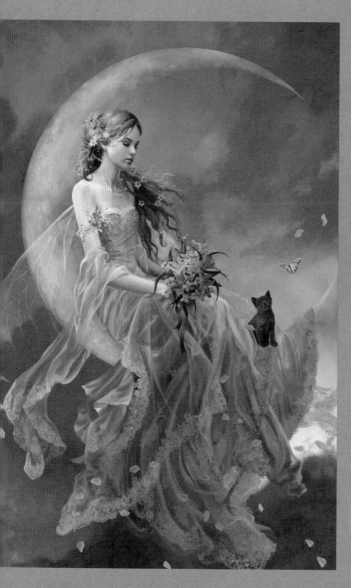

Windmoon *(left)*
Nene Thomas

Nene Thomas, who now creates her paintings with digital mediums, brings to life the Windmoon fairy in delicate tones of blue and gray. The washes of the sky and clouds are set against the careful detailing of the fairy's clothing and gossamer wings.

Mirror of Illusion *(right)*
Chris Down

A mirror of illusion is a perfect foil by which characters can pass from the real world into an imagined one. In Chris Down's digital painting, the viewer is presented with a woman who is bridging both worlds. The highly realistic rendering of the figure in the foreground enhances the juxtaposition of the two worlds.

Queen of Hearts *(above)*
Sharon George

Inspired by the ancient European tradition of the fairy queen, Sharon George creates a digital painting rich with meaning. Behind the queen, to the right, is the face of her groom, the Green Man and Lord of the Forest. The purple of the clothing symbolizes the queen's royal status, while joy is evoked by the hummingbirds, and hope and promise by the flowers.

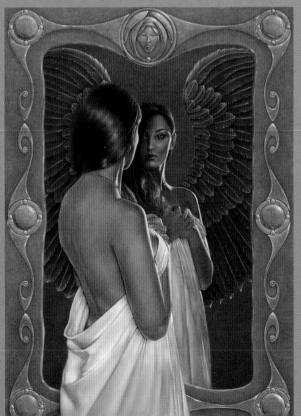

The Crysalis *(left)*
Cari Buziak

Using watercolor on rag paper, Cari Buziak creates an image of a fairy spirit about to emerge like a butterfly. The decorative border of branches, buds, and flowers is also springing into life as one follows the border from its base to the top. The use of watercolor and the natural imagery of the border that encloses the dormant spirit give the painting a timeless quality.

Into this World *(right)*
Kajsa Flinkfeldt

Kajsa Flinkfeldt's painting glows with the vibrant tones of the watercolor and gouache. Yet it maintains a gentle ephemeral quality as the crouching fairy edges forward from her world into ours.

Dragons and beasts

Dragons and strange beasts are classic features of fantasy painting that can be introduced in any way the artist chooses, from a pitched battle to an adventure in a far-off land. They even have the ability to turn what may appear at first sight to be a realistic scene into one straight out of an imagined world.

Dragon Slayer
Jeremy McHugh

In Jeremy McHugh's digital painting the hero is dwarfed and seemingly trapped by the mass of the dragon, yet with his glowing sword he may still win the battle. The drama of this scene of fantasy combat is heightened by the almost hyper-real rendering of the dragon and the slayer, combined with their positioning on a precipitous cliff above a sea of flames.

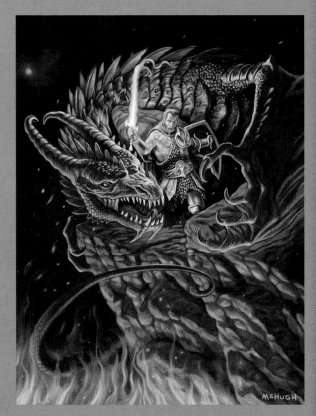

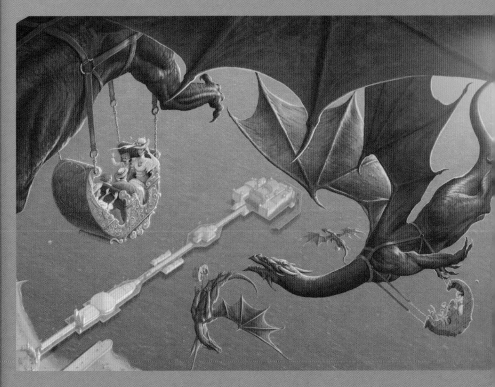

Dragon Rides
Martin McKenna

Here, Martin McKenna has combined historical costume and holiday thrill-seeking by the seaside with the world of fantasy to create a highly original image. The restricted range of colors, rendering, and costume lend it a gentle quality, yet at the same time it is also deeply exciting with the dragons swooping below and the high viewpoint as if we are in a dragon-ride carriage too.

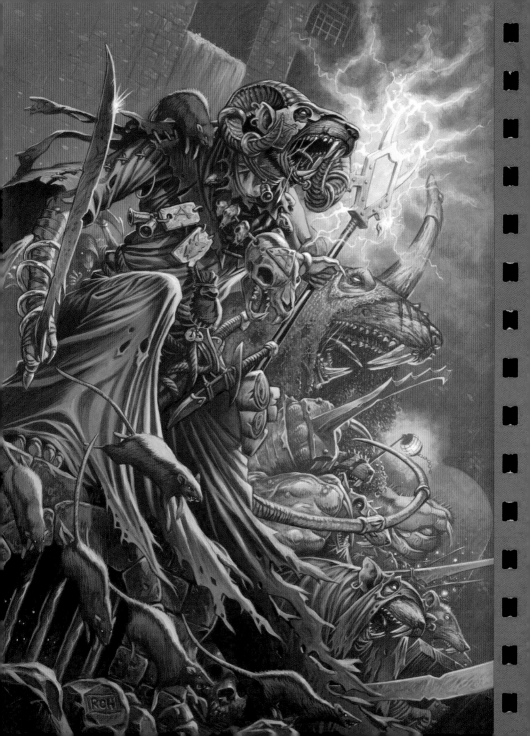

Thanquol *(left)*
Ralph Horsley

Ralph Horsley creates gritty and dramatic images, as shown in this cover to the novel *Grey Seer* by C.L. Werner. Thanquol, the protagonist, is unnervingly half human half rat and is accompanied by a vicious band of fighters. The vivid red and orange tones increase the tension, as does the positioning of the viewer as if about to be trampled by Thanquol.

Draco Niger Grandis *(below)*
Mark Harrison

Mark Harrison creates an almost timeless image by setting a hyper-real portrayal of a dragon before a decorative plaque ornamented with a dragon-filled landscape and Latin script that warns of the dangers of fiery dragons. Painted in acrylic with bronze powder, Harrison draws on the influence of Balinese and Thai art for his unique fantasy painting.

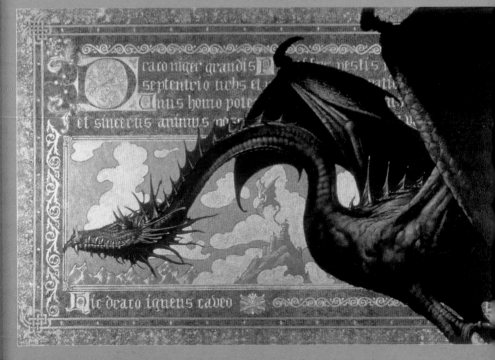

Pilum *(below)*
Grey Thornberry

Pilum has a science-fiction quality
as the high-tech armor-clad female
warrior fights with the many-limbed
amorphous creature, reminiscent of
a giant squid. Yet Grey Thornberry's
inspiration was the Roman javelin,
the pilum, with which we see the
woman pierce the body of the
squid, releasing the purple ink
billowing behind the creature.

Remembering Spring *(right)*
Heather Hudson

Painting in oils, Heather Hudson
creates a tender image of an
immense creature rescuing a
delicate bird that would perish in
the snow. Hudson plays with the
viewer's perceptions by setting the
landscape and the bird in a
recognizably human world, yet the
detailing of the figure accentuates
his strangeness.

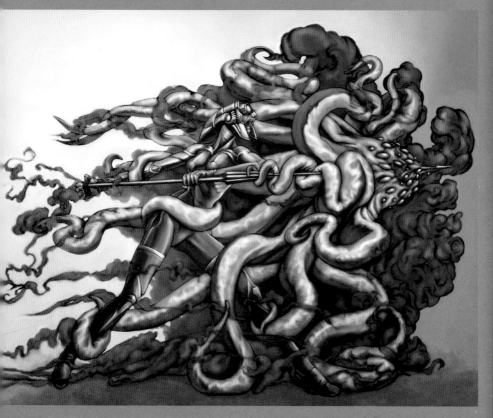

Lunar Magic *(right)*
Anne Stokes

The aged stone decorative border
and the dark mountainous
landscape dimly lit by the moon,
which can be glimpsed behind the
dragon in the foreground, firmly set
the creatures in a monumental and
enduring magical world.

Monster Attack *(left)*
Jon Hodgson

Painting digitally, Jon Hodgson
transforms a landscape into a harsh
environment where humans must
do battle with strange giant beasts.
The muted earthy tone and loose
handling of paint emphasise the
bleakness of this imagined world.

Distant worlds

In films, comics, animation, and novels we have long been fascinated
by the idea of other realities, perhaps far off in space or in worlds that
lie alongside our own, and they provide a rich environment in which
fantasy artists can explore their own ideas.

Alone
Kieran Yanner

The vastness of space is strongly captured in Kieran Yanner's image as diminutive spaceships travel separately through this fiery inhospitable corner of the universe.

Lake Base *(below)*
Franco Brambilla

Here, Franco Brambilla has taken an old postcard bought in a street market and reworked it digitally to create a surprising alpine scene, as if it were a holiday postcard from another world. He worked with 3D and Photoshop before repainting the entire picture in Corel Painter.

It's Alive *(right)*
Paul Bielaczyc

For this ominous book cover, Paul Bielaczyc worked with pastel and colored pencil to create a highly expressive landscape.

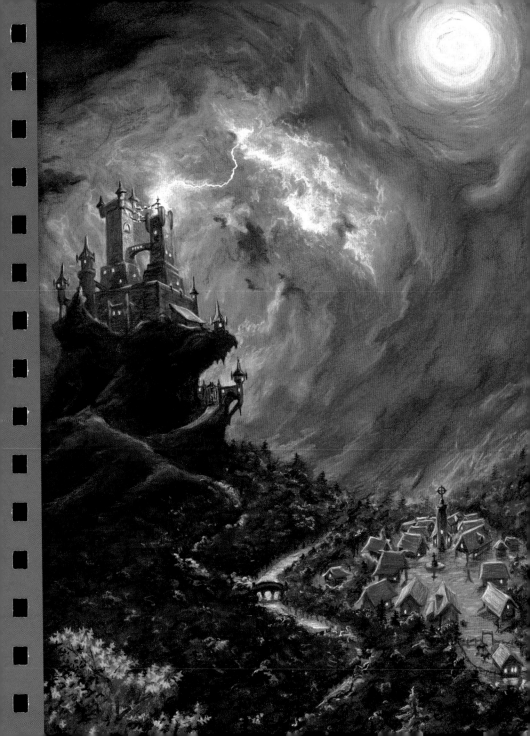

To Ride Hell's Chasm *(left)*
Janny Wurts

Painted for the spine of her novel of the same title, Janny Wurts creates a dramatic and precipitous landscape in which even the dragons are vulnerable to attack.

Rubblewerk *(right)*
Bob Hobbs

These three images are from a series. For each work, Bob Hobbs starts with a pen-and-ink drawing, which he then colors digitally. The dark outlines of the elements and the smooth application of paint are ideal for the armor-style clothing and science-fiction hardware.

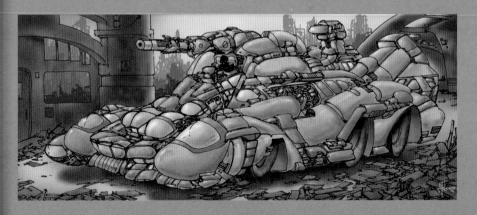

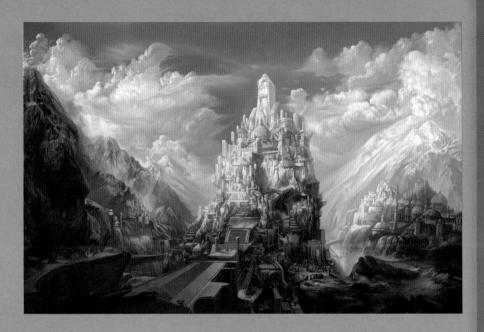

Supreme City *(above)*
Lorland Chen

Working with Painter and Photoshop, Lorland Chen seeks to express the spirit of Chinese art within his work. The delicate and meticulous detail of the fantastical hilltop city and towers compel the viewer to study them in detail.

Abandoned Temple *(right)*
Rob Alexander

At first glance one might think Rob Alexander's painting shows the ruin of a grand cathedral with its ornate stonework and statues, yet features such as the decorated pillars in the foreground and the water tumbling into the right show us it is the temple of a long-lost world.

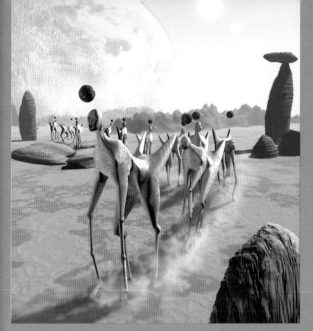

The Herd *(left)*
Alan F. Beck

Alan F. Beck challenges the viewer's thoughts of what the herd of animals might be and injects a striking surrealist edge as the alien creatures travel across the strange glowing landscape.

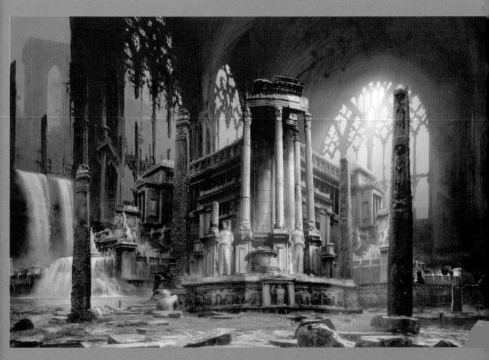

Mythology
and folklore

As stories and shared beliefs, myths, legends, and folklore offer
rich sources for the fantasy artist both for inspiration and for new
interpretations of classic themes.

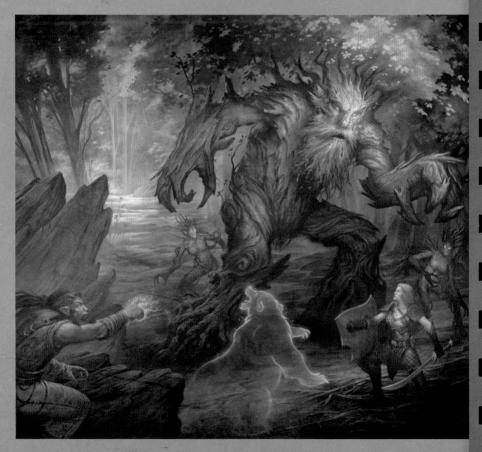

Hedgewitch II *(right)*
Marc Potts

Marc Potts takes inspiration from
folklore, mythology, and nature for
his fantasy art, and here he draws
on the European tradition of
witchcraft. By forming the figure
from branches, leaves, and feathers
he aligns the practice with the
natural world.

Forest Ambush *(left)*
Howard Lyon

The setting could be an ancient
wood, yet in this dramatic fantasy
combat scene humans and creatures
fight a humanized tree. In folklore
and some pagan religions, trees
were regarded as having a face and
a soul, and it is a compelling theme
for many artists and writers.

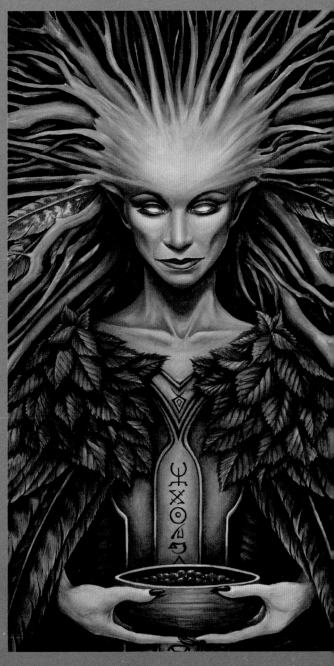

Gold and Silver
Randy Gallegos

The precious metals of gold and
silver have long held special
meaning for cultures throughout the
world. Here, the ornately decorated
clothing of the two imposing
figures, who could be rulers of
another world, glow with the
qualities of the metals.

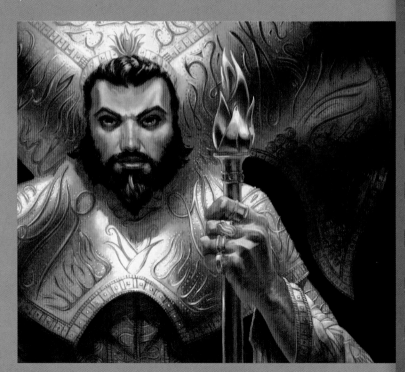

Laurenmaid
Tania Henderson

Mermaids are a popular mythological creature of the sea, and through the realistic rendering of the water and the naturalistic posing of the mermaid, Tania Henderson almost brings her from the imagined world into the human.

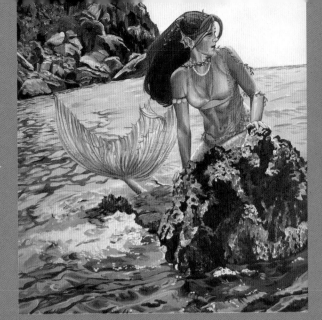

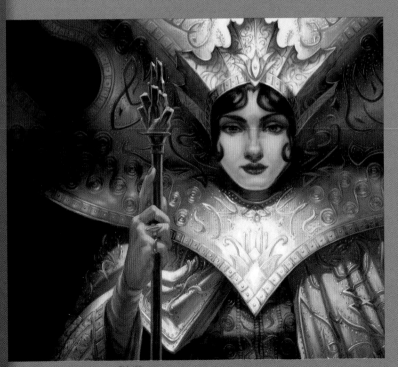

Mermaid and Baby *(right)*
Tina Renae

Tina Renae paints a serene aquatic scene in acrylic and mixed mediums. The meticulous detail of the sea floor and the mermaid with her baby, caught in the shaft of light, draws the viewer to the tranquility of this fantasy world.

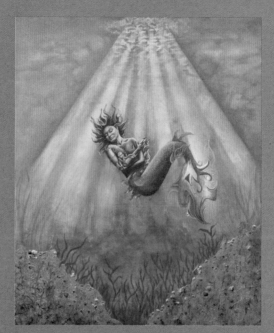

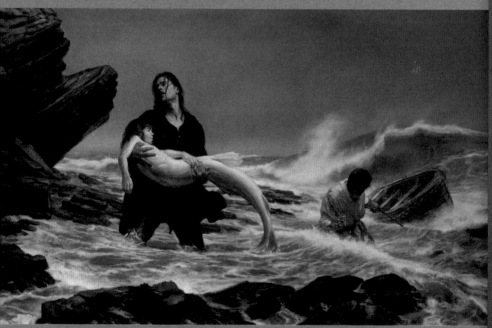

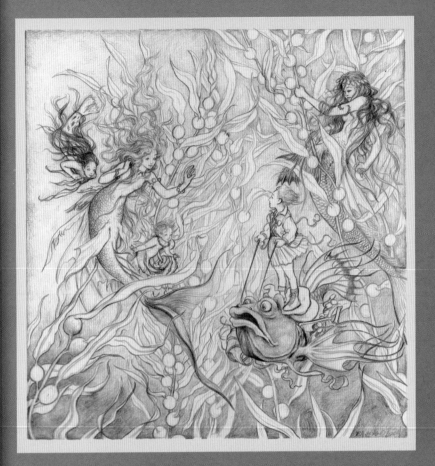

Progeny *(left)*
Donato Giancola

Working in oil, Donato Giancola has painted an epic work in the realist tradition. The drama of this image suggests it is but one scene from a compelling fantasy adventure.

She Travelled by Catfish *(above)*
Patricia Ann Lewis-MacDougall

Drawn in brown pencil on colored matt board, the use of line, shading, highlights, and the paper's surface texture combine to create a subtle and delightful underwater scene.

Mephistopheles *(left)*
Mike Nash

Mephistopheles is one of the names given to the devil, and in his digital painting Mike Nash makes his own interpretation to create an unsettling figure swathed in a billowing red robe, smoke, and fire, and whose face is obscured by armor.

Dark Djinn *(right)*
Thomas Baxa

The rapid movement of the oil paint, strong modeling of the spirit, and positioning of the viewer as if the djinn has appeared above all contribute to Thomas Baxa's striking portrayal of this supernatural spirit.

The unexpected

One of the appealing qualities of fantasy art is that it never ceases to surprise, and in being art of the imagination artists can freely pursue any ideas they choose. This combined with the diverse choice of media available continues to make fantasy art an exciting genre to work in.

Dead Butler *(left)*
Corlen Kruger

Dead Butler is one of a series of macabre heads made by Corlen Kruger. Working digitally, Kruger develops the head with strong painterly brushstrokes that enhance the unnerving feel of the piece.

Wicked Enchantment *(right)*
Don Maitz

This acrylic painting was the cover image to an edition of a novel of the same title. Don Maitz creates an eerie atmosphere through the almost human statues and the gargoyle, ready to pounce above them, juxtaposed with the vibrant parrot in the foreground.

Lady with a Bosch Egg *(right)*
Jasmine Becket-Griffith

Painting in acrylic, Jasmine Becket-Griffith develops a striking portrait by stepping back in time to incorporate into her signature style of big-eyed feminine figures the influence of the early Renaissance painter Hieronymus Bosch.

Silverback *(below)*
Chris Quilliams

Chris Quilliams's acrylic painting draws on the iconography of high-tech combat yet takes the viewer further into a fantasy world with the highly realistic rendering of the armed and armored humanized gorilla assertively staring at us.

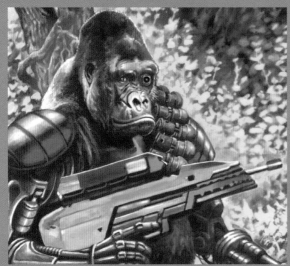

Pig Wishes to Escape This World *(right)*
David Ho

This digital painting is from a series in which David Ho explores diverse themes around creatures that are half human half pig. The muted colors of the paint and metallic textures emphasise the harshness of this imagined world.

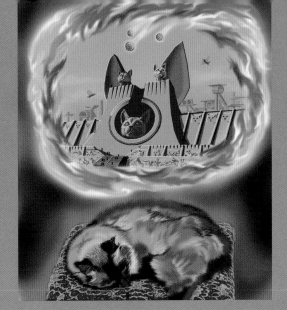

Cat Utopia *(right)*
Frank Wu

Made for the cover of the *Feline Mewsing* fanzine, Frank Wu offers a humorous take on the dream world of a cat.

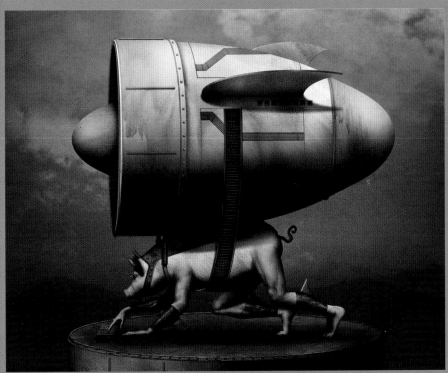

Index

Credits

Quarto would like to thank the following artists:

R. Stephen Adams www.rstephenadams.com
Rob Alexander www.robalexander.com
 © Wizards of the Coast LLC.
 Images used with permission: *The Exalted Angel, Aerial View, Endless Maze, Abandoned Temple.*
Thomas M. Baxa www.baxaart.com
Alan F. Beck www.alanfbeck.com
Jasmine Becket-Griffith www.strangeling.com
Paul Bielaczyc www.aradani.com
Jonathon Earl Bowser www.jonathonart.com
Franco Brambilla www.francobrambilla.com
Cari Buziak www.aon-celtic.com
Lorland Chen www.lorlandc.com
Chris Down www.chrisdown.co.uk
Kajsa Flinkfeldt www.flinglingart.com
Randy Gallegos www.gallegosart.com
 ©Wizards of the Coast LLC.
 Image used with permission: *Mosquito Guard*
Vanessa Gaye-Schiff www.forestfey.co.za;
 www.vanessagaye.com
Sharon George www.fantasy-goddess-art.com
Donato Giancola www.donatoart.com
Mark Harrison
 www.paintingsbymarkharrison.com
Tania Henderson www.taniahenderson.com
Stephen Hickman www.stephenhickman.com
David Ho www.davidho.com
Bob Hobbs www.moordragonarts.com
Jon Hodgson www.jonhodgson.com
Ralph Horsley www.ralphhorsley.co.uk.
 ©2009 Games Workshop: *Thanquol*;
 ©Wizards of the Coast LLC.
 Image used with permission: *Divine Power*
Heather Hudson
 www.studiowondercabinet.com

Ruan Jia www.ruanjia.com
Corlen Kruger www.corlenkruger.com
Patricia Ann Lewis-MacDougall
 www.shadow-bird.blogspot.com
Eric Lofgren www.ericlofgren.net
Howard Lyon www.howardlyon.com
 ©Wizards of the Coast LLC.
 Images used with permission: *Wastelands, Deepstone Sentinel, Forest Ambush*;
 ©2009 Paizo Publishing: *Mephistopheles.*
Jeremy McHugh www.mchughstudios.com
Martin McKenna www.martinmckenna.net
Don Maitz www.paravia.com/donmaitz.
 Art ©Don Maitz.
Mike Nash www.mike-nash.com
Minae Takada www.minae.info
Chris Parsons
 http://chrisparsons.cgsociety.org/gallery/
Marc Potts www.marcpotts.com
Scott Purdy www.scottpurdy.net
Chris Quilliams http://cquilliams.epilogue.net
Tina Renae www.tinarenaeart.com
Anne Stokes www.annestokes.com
Nene Thomas www.nenethomas.com
Grey Thornberry www.greystudio.com
Frank Wu www.frankwu.com
Janny Wurts www.paravia.com/jannywurts.
 Art ©Janny Wurts.
Kieran Yanner www.kieranyanner.com.
 All images ©2009 SpaceTime Studios, LLC.
 All Rights Reserved.

Wizards of the Coast, Magic: The Gathering, Dungeons & Dragons, and Magic™ card art are trademarks of Wizards of the Coast LLC. Images used with permission of Wizards of the Coast LLC.

Some of the text originally appeared in the *Encyclopedia of Fantasy and Science Fiction Art Techniques* by John Grant and Ron Tiner. Some images have also been drawn from this source, and Quarto would like to thank the original artists: Paul Campion, Steve Crisp, Henry Flint, Phil Gascoigne, David A. Hardy, and Ron Tiner.

Quarto thanks the following artists whose works have been reproduced before: Kevin Crossley, Michael Cunningham, Glenn Fabry, Jon Hodgson, Corlen Kruger, Patrick McEvoy, Liam Sharp, Anne Stokes, Lee Smith, Keith Thompson, Kevin Walker, David White.

For images used on page 94 Quarto would like to thank: Glenn Fabry, Michael Cunningham, and Liam Sharp.

While every effort has been made to credit contributors, Quarto would like to apologize should there be any omissions or errors, and would be pleased to make the appropriate correction for future editions of the book.

Caption page 2: Anne Stokes *Dragon Lord*